LONDON
architecture & design

Edited and written by Sabina Marreiros and Jürgen Forster
Concept by Martin Nicholas Kunz

teNeues

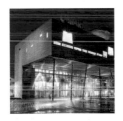

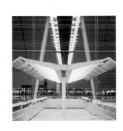

to see . culture & education

to see . public

to stay . hotels

to go . eating, drinking, clubbing

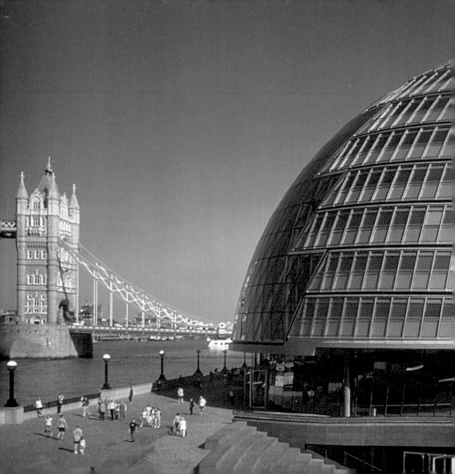

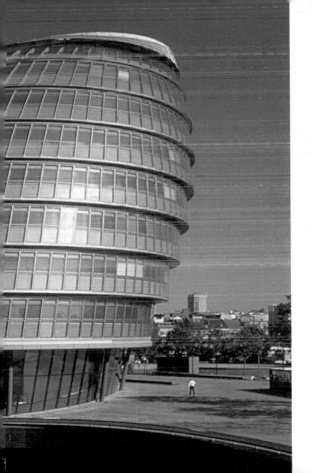

introduction

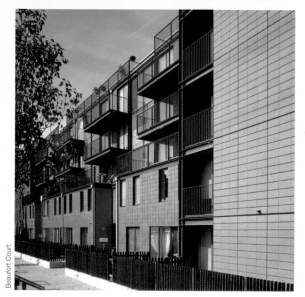

Beaufort Court

West Ham Station

The continuously expanding financial and commercial center is primarily shaping its future on the large areas along the riverbank, which have become vacant through industrial migration. Lively construction activity is currently dominant, especially in locations near the city south of the Thames. The volume at hand depicts outstanding architecture based on recently developed residential buildings, office blocks, museums, and galleries. The newest shops, bars, restaurants and hotels illustrate the current trends in London interior design.

Die stetig wachsende Handels- und Finanzmetropole gestaltet ihre Zukunft vor allem auf den großen Arealen entlang der Flussufer, welche durch die Abwanderung der Industrien frei wurden. Derzeit herrschen besonders in den citynahen Lagen südlich der Themse rege Bautätigkeiten. Der vorliegende Band zeigt herausragende Architektur anhand von jüngst entstandenen Wohnhäusern, Bürotürmen, Museen und Galerien. Die neuesten Shops, Bars, Restaurants und Hotels bilden die aktuellen Strömungen des Londoner Interieurdesigns ab.

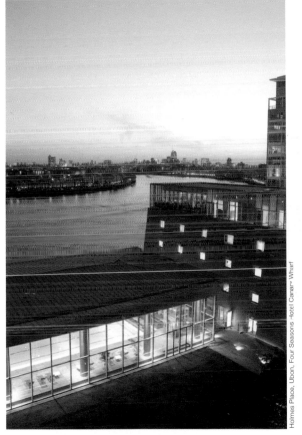

Holmes Place, Ubon, Four Seasons Hotel Canary Wharf

9

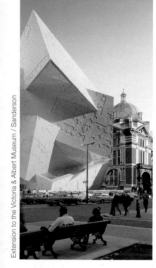

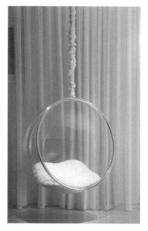

La métropole commerciale et financière en croissance constante organise son avenir notamment sur les grands espaces le long des rives du fleuve qui ont été libérées par le départ des industries. Actuellement, on construit beaucoup, notamment sur la rive sud de la Tamise, à proximité de la Cité. Le présent ouvrage vous fait découvrir une excellente architecture sur la base des maisons d'habitations, tours de bureaux, musées et galeries construites très récemment. Les nouveaux magasins, bars, restaurants et hôtels concrétisent les courants actuels du design d'intérieur londonien.

01 . **London Bridge Tower**
Renzo Piano Building Workshop
Broadway Malyan
Ove Arup & Partners

2009
32 London Bridge Street
Southwark SE1

www.londonbridgetower.com
www.rpwf.org

La metrópolis comercial y financiera en constante crecimiento ve conformarse su futuro sobre todo en las amplias zonas que flanquean la orilla del río y que quedaron libres al trasladarse las industrias. Actualmente se desarrolla una frenética actividad constructora, en particular en el área cercana a la City al sur del Támesis. El presente volumen muestra una arquitectura notable a través de edificios de viviendas, torres de oficinas, museos y galerías de muy reciente construcción. Lo último en tiendas, bares, restaurantes y hoteles ilustra las tendencias actuales en el diseño londinense de interiores.

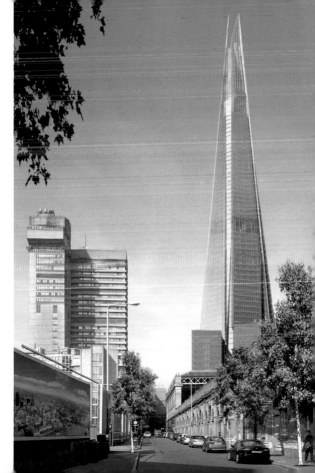

to see . living
office
culture & education
public

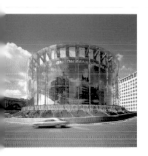 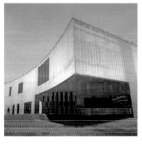 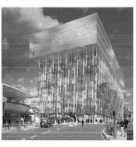

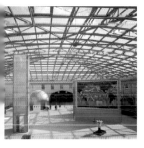 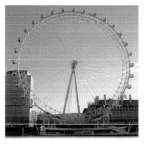 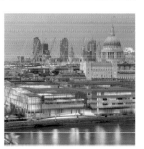

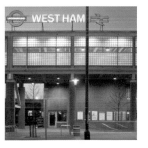

Kings Wharf

Stephen Davy Peter Smith Architects Ltd
MLM Consulting Engineers

2001
297-301 Kingsland Road
Hackney E8

www.davysmitharchitects.co.uk

The building on the former petrol-station grounds consists primarily of duplex flats. An open workplace can be set up in the mezzanine storey. Underneath that is the living level including bedroom, bath, clearly defined kitchen area, and bright, two-storey living space.

Das Gebäude auf dem ehemaligen Tankstellengelände besteht vorwiegend aus Duplex-Wohnungen. In dem Mezzaningeschoss kann ein offener Arbeitsplatz eingerichtet werden; darunter befindet sich die Wohnebene mit Schlafzimmer, Bad, klar definiertem Küchenbereich und dem hellen, zweigeschossigem Wohnraum.

Le bâtiment construit sur le terrain d'une ancienne station-service est composé en majorité d'appartements en duplex. Dans la mezzanine, il est possible d'installer un bureau ouvert, au dessous de celle-ci se trouve les pièces d'habitation avec chambre, salle de bain, coin cuisine démarqué clairement et une salle de séjour claire à deux niveaux.

El edificio situado en los antiguos terrenos de la gasolinera consta principalmente de viviendas dúplex. En el entresuelo se puede habilitar un lugar de trabajo abierto, quedando abajo el nivel de vivienda con dormitorio, baño, zona de cocina claramente definida y una luminosa superficie habitable en dos plantas.

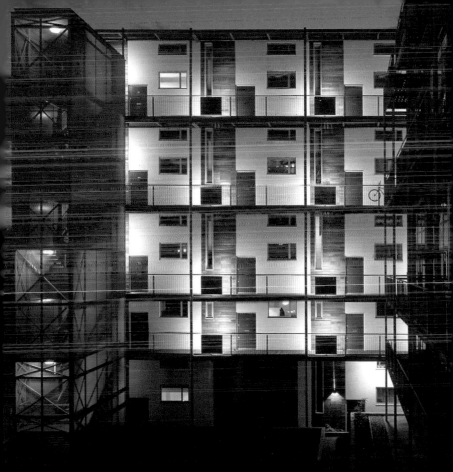

Warburton Terrace

Walter Menteth Architects
MK Builders

2001
Warburton Terrace
Walthamstow E17

www.waltermenteth.com

This residential project made from two very different structures lies in the heart of the countryside. The southern part is designed to be light and open. As with the community areas, the six flats have direct access to the garden. The northern part of the house has a heavy and withdrawn effect; it houses side rooms.

Mitten im Grünen liegt dieses Wohnprojekt aus zwei sehr unterschiedlichen Baukörpern. Der südliche ist leicht und offen konstruiert. Die sechs Appartements haben, wie auch der Sozialraum, direkten Zugang zum Garten. Der nördliche Teil des Hauses wirkt schwer und verschlossen; er beherbergt die Nebenräume.

C'est en pleine verdure que se trouve ce projet d'habitation composé de deux corps de bâtiments très différents. Celui situé au sud est de construction légère et ouverte. Les six appartements ont de même que l'espace social, accès direct au jardin. La partie nord de l'immeuble semble massive et fermée, elle abrite les dépendances.

En medio de una zona verde se encuadra este proyecto de viviendas en dos cuerpos constructivos muy diferenciados. El del sur es ligero y construido en forma abierta. Los seis apartamentos disponen, como la zona social, de acceso directo al jardín. La parte norte del edificio tiene un aspecto más pesado y cerrado, y alberga las piezas auxiliares.

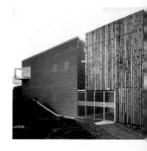

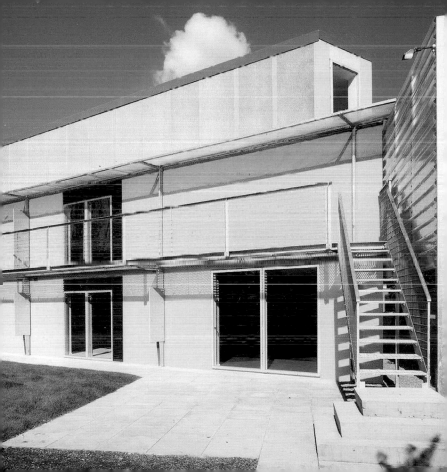

Iroko House
Coin Street

Haworth Tompkins
Price & Myers LLP

2002
Coin Street
South Bank SE1

www.haworthtompkins.com

Rigid shell, soft core. The complex presents itself toward the street as urbane but the garden façade is open and soft. The inner courtyard is for the exclusive use of the residents, a public passageway was deliberately waived. The planned community centre with offices, day nursery and bar is designed to close the open yard side.

Harte Schale, weicher Kern. Zur Straße hin gibt sich der Komplex urban, die Gartenfassade jedoch ist offen und weich. Der Innenhof ist exklusiv für die Anwohner, auf einen öffentlichen Durchgang wurde bewusst verzichtet. Das geplante Gemeinschaftshaus mit Büros, Kinderkrippe und Bar soll die offengebliebene Hofseite schließen.

Une coque dure, un noyau tendre. Du côté rue, le complexe donne une impression urbaine, du côté jardin néanmoins, il est ouvert et tendre. La cour intérieure est uniquement pour les habitants, il a été renoncé consciemment à un passage public. La maison communautaire en planification avec des bureaux, une crêche et un bar doit fermer le côté de la cour resté ouvert.

Corteza dura, núcleo blando. Hacia la calle, el complejo presenta un aspecto urbano, pero la fachada del jardín es abierta y suave. El patio interior es exclusivo para los residentes; se renunció conscientemente a habilitar un paso público. Hay proyectado un edificio colectivo con oficinas, guardería y bar que cerraría el lado abierto del patio.

18

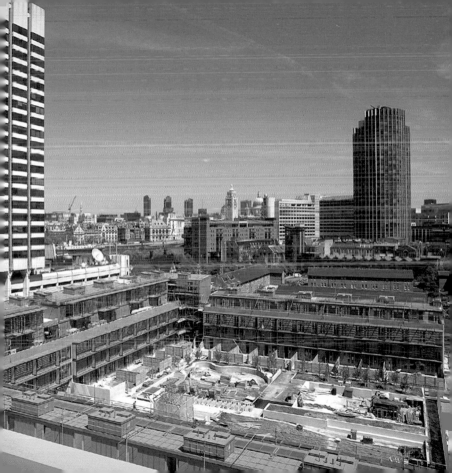

no. one
Centaur Street

de Rijke Marsh Morgan / dr.m.m.
Adams Kara Taylor

North Elevation

East Elevation

2003
1 Centaur Street
Lambeth SE1

www.drmm.co.uk

This residential building has its back turned toward the Eurostar viaduct but opens widely toward the front. The four flats are conceived as a combination of continental (horizontal) flats and English (vertical) houses. The side rooms are attached to the two-storey main rooms.

Seinen Rücken wendet dieses Wohnhaus dem Eurostarviadukt zu, nach vorne aber öffnet es sich weit. Die vier Wohnungen sind als Kombination aus kontinentalen (horizontalen) Wohnungen und englischen (vertikalen) Häusern konzipiert. Die Nebenräume sind in die zweigeschossigen Haupträume eingehängt.

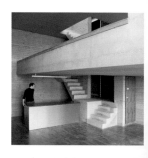

Cet immeuble d'habitation tourne le dos au viaduc de l'Eurostar, mais vers l'avant, il s'ouvre largement. Les quatre appartements sont conçus comme une combinaison des appartements continentaux (horizontaux) et des maisons anglaises (verticales). Les dépendances sont insérées dans les pièces principales à deux étages.

Aunque este edificio de viviendas da la espalda al viaducto Eurostar, hacia delante presenta un carácter abierto. Las cuatro viviendas están concebidas como una combinación de las viviendas continentales (horizontales) e inglesas (verticales). Las piezas auxiliares dependen de las salas principales en dos plantas.

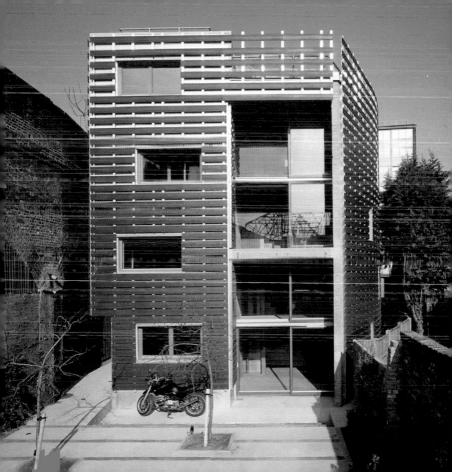

Greenwich Millennium Village

Proctor and Matthews Architects
URS Corporation

2002
West Parkside
Greenwich SE10

www.proctorandmatthews.com

The second construction phase expands the existing project by 372 living units. There are three flat typologies, which enable a high degree of building density through row construction and tiers. The floor plans are very flexible on account of attachable rooms and the use of sliding partition walls.

Die zweite Bauphase erweitert das bestehende Projekt um 372 Wohneinheiten. Es gibt drei Wohnungstypologien, die durch Reihung oder Stapelung eine hohe Bebauungsdichte ermöglichen. Die Grundrisse sind aufgrund zuschaltbarer Räume und der Verwendung von Schiebewänden sehr flexibel.

La deuxième phase des travaux étend le projet existant à 372 unités d'habitation. Il existe trois typologies d'appartements, qui permettent une haute densité de construction par accolement ou empilage. Les plans sont très flexibles en raison de pièces modulables et grâce à l'utilisation de murs coulissants.

La segunda fase de la construcción amplía el proyecto existente en 372 unidades residenciales. Hay tres tipologías de viviendas que permiten una alta densidad constructiva por alineamiento o construcción en altura. Las plantas son muy flexibles gracias a salas añadibles y al uso de paredes corredizas.

The Woodyard

Huf Haus
Willy Neis & Partner

2002
The Woodyard
Dulwich SE21

www.huf-haus.de

This small settlement is found on the edge of the Dulwich Nature Park. In order to keep the discernable structural mass as small and light as possible, all secondary rooms are located in the basement. The components of the nine residential buildings with wooden framework are industrially prefabricated and assembled on-site.

Diese kleine Ansiedlung befindet sich am Rande des Dulwich Naturparks. Um die wahrnehmbaren Baumassen so klein und leicht wie möglich zu halten, befinden sich alle Nebenräume im Untergeschoss. Die Bauteile der neun Wohnhäuser mit Holztragwerk wurden industriell vorgefertigt und vor Ort montiert.

Ce petit lotissement se trouve en bordure Dulwich Naturparks. Pour conserver une impression de construction le plus petit et léger possible, toutes les dépendances se trouvent en sous-sol. Les matériaux de construction des neuf maisons d'habitation à structure en bois sont de préfabrication industrielle et ont été montés sur place.

Este pequeño asentamiento limita con el parque natural Dunwich. Para mantener las masas constructivas visibles lo más pequeñas y ligeras posibles, todas las piezas auxiliares se hallan en el sótano. Las partes constructivas de las nueve viviendas con estructura de madera se prefabricaron industrialmente y se montaron in situ.

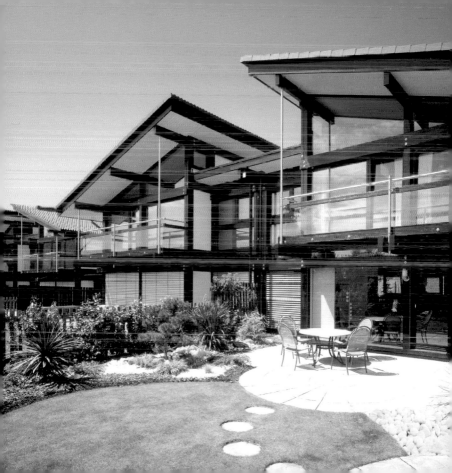

Gwynne Road

Walter Menteth Architects
Barton Engineers

1999
Gwynne Road
Battersea SW11

www.waltermenteth.com

Lively contrasts of materials, colors, and forms characterise this project. The cut of the structure defines the central development axis. The strict façades provide little information about the functions lying behind. Each of the eight housing units is allocated a private garden and parking space.

Lebendige Kontraste der Materialien, Farben und Formen bestimmen dieses Projekt. Der Einschnitt im Baukörper definiert die zentrale Erschließungsachse. Die strengen Fassaden geben wenig Auskunft über die dahinterliegenden Funktionen. Jeder der acht Wohneinheiten ist ein privater Garten- und Stellplatzbereich zugeordnet.

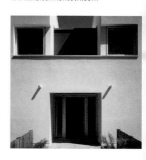

Le contraste vivant des matériaux, des couleurs et des formes détermine ce projet. La coupure dans le corps de bâtiment définit l'axe de viabilisation central. Les façades austères donnent peu de renseignements sur les fonctions qu'elles abritent. Chacune des huit unités d'habitation dispose d'un jardin privé et d'une place personnelle de parking.

Los vivos contrastes de materiales, colores y formas determinan este proyecto. El corte en el cuerpo constructivo define el eje de urbanización central. Sus severas fachadas proporcionan escasa información sobre las funciones que se desarrollan tras ellas. Cada una de las ocho unidades residenciales tiene asignada una zona privada de jardín y aparcamiento.

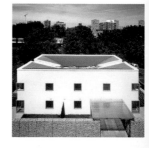

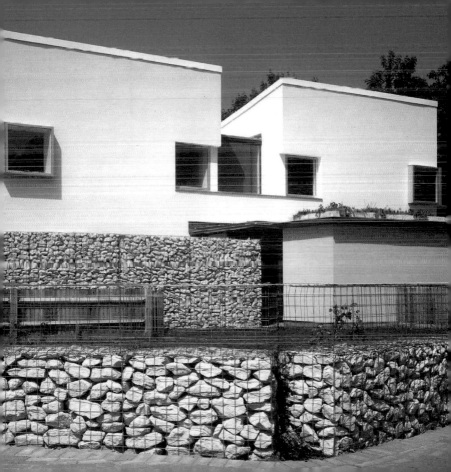

Beaufort Court

Feilden Clegg Bradley Architects LLP
Michael Barclay Partnership

2003
Lillie Road
Fulham SW6

www.peabody.org.uk
www.feildenclegg.com

65 housing units are grouped around the sports grounds on the landscaped inner courtyard. One- and two-storey flats are located in the higher northern building. Terraced houses stand in the south; the small community center in the middle creates the eastern edge.

Um die Sportanlagen auf dem begrünten Innenhof gruppieren sich 65 Wohneinheiten. Im höheren Nordgebäude befinden sich ein- und zweigeschossige Wohnungen. Im Süden stehen Reihenhäuser, das kleine Gemeinschaftshaus in der Mitte bildet die östliche Platzkante.

Autour des installations sportives sur la cour intérieure verte se groupent 65 unités d'habitations. Dans le bâtiment nord, plus élevé, se trouvent des appartement à un et à deux niveaux. Au sud se trouvent des maisons accolées, la petite maison communautaire du milieu constituant le bord est de la place.

Alrededor de las instalaciones deportivas del patio interior ajardinado se agrupan 65 unidades residenciales. El más alto edificio norte alberga viviendas de una y dos plantas. Al sur se hallan los adosados, el pequeño edificio comunitario del centro forma el borde este.

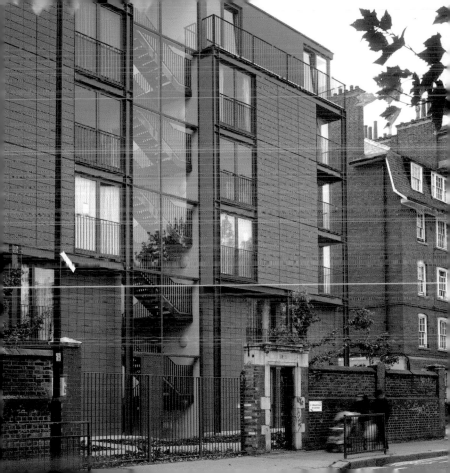

1 Churchill Place
Canary Wharf

HOK Hellmuth, Obata & Kassabaum
Cantor Seinuk Group

2004
1 Churchill Place
Canary Wharf E14

www.hok.com

The 156-meter high Barclays Bank PLC headquarters is currently emerging in the docklands where approximately 5000 employees are to find space on 33 floors. A building-high atrium zone, which consists of five elements stacked on each other, guarantees optimal, natural workspace lighting.

In den Docklands entsteht derzeit die 156 Meter hohe Zentrale der Barclays Bank PLC, wo auf 33 Geschossen etwa 5000 Mitarbeiter Platz finden werden. Eine gebäudehohe Atriumzone, die aus fünf aufeinandergestapelten Elementen besteht, garantiert eine optimale, natürliche Belichtung der Arbeitsplätze.

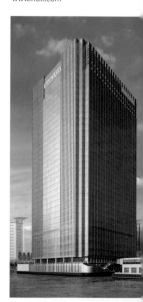

Dans les Docklands se trouve actuellement en construction la centrale de 156 mètre de haut de la Barclays Bank PLC, où seront abrités sur 33 étages environ 5000 collaborateurs. Une zone d'atrium à la hauteur du bâtiment et constituée de 5 éléments empilés les uns sur les autres garantit un éclairage optimal et naturel des lieux de travail.

En las Docklands se encuentra actualmente la central de Barclays Bank PLC, de 156 metros de altura, lugar de trabajo de alrededor de 5000 trabajadores repartidos en 33 plantas. Una zona de atrio de la altura de un edificio, compuesta por cinco elementos apilados, garantiza una iluminación natural óptima de los lugares de trabajo.

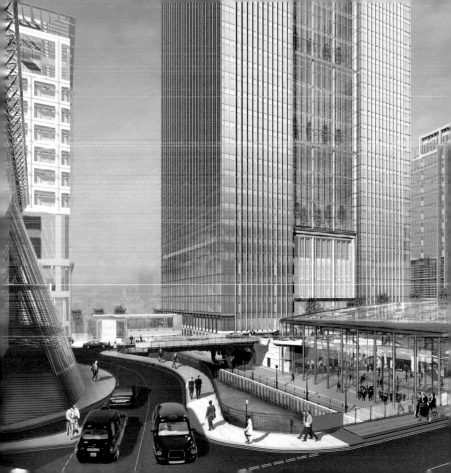

88 Wood Street

Richard Rogers Partnership
Ove Arup & Partners

1999
88 Wood Street
Barbican EC2

www.richardrogers.co.uk

An exterior frame emphasises the three connected terraced structures and lends depth to the façades. Slim, glass-faced service towers support the building's vertical dynamism. The greatest possible transparency emerges through the limited proportion of closed-in façade areas.

Ein außen liegendes Tragwerk betont die drei abgestuften, miteinander verbundenen Baukörper und verleiht den Fassaden Tiefe. Schlanke, flächig verglaste Servicetürme unterstützen die vertikale Dynamik des Gebäudes. Durch den geringen Anteil geschlossener Fassadenflächen entsteht größtmögliche Transparenz.

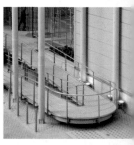

Une structure située en extérieur accentue les trois corps de bâtiments étagés et reliés entre eux tout en conférant de la profondeur à la façade. Des tours de service élancées et recouvertes de verre soutiennent la dynamique verticale du bâtiment. La faible proportion de surfaces de façade fermées crée la transparence la plus grande possible.

Una estructura portante de ubicación externa destaca los tres cuerpos constructivos escalonados conectados entre sí, al tiempo que confiere profundidad a las fachadas. Las delgadas y completamente acristaladas torres de servicios apoyan la dinámica vertical del edificio. La reducida proporción de superficies de fachada cerradas permite la máxima transparencia.

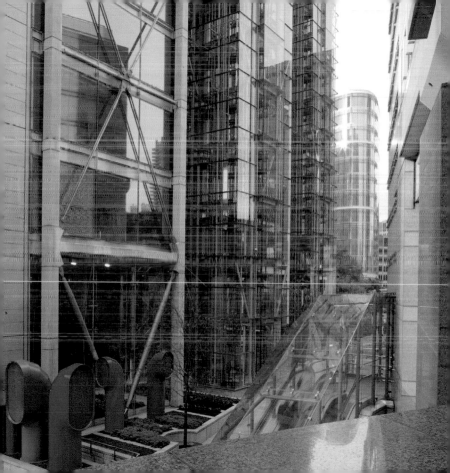

Atlantic House

Rolfe Judd
WSP Group

2001
45-50 Holborn Viaduct
Holborn EC1

www.rolfe-judd.co.uk

The restoration and integration of the Victorian gate lodge was of great significance during the development of this office building. Its elements of differing heights react to the partially historic constructional context.

Die Wiederherstellung und Eingliederung des viktorianischen Torhauses war bei der Entstehung dieses Bürogebäudes von großer Bedeutung. Seine unterschiedlich hohen Elemente reagieren auf den teilweise historischen baulichen Kontext.

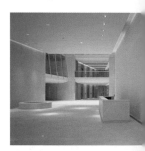

La reconstruction et l'insertion de la maison à porche victorienne était de grande signification lors de la construction de ce bâtiment de bureaux. Ses éléments de hauteur différente réagissent au contexte en partie historique et architectural.

Se prestó gran atención a la restauración e integración de la casa de portal victoriana al crear este edificio de oficinas. Sus elementos de distinta altura son una respuesta al contexto constructivo parcialmente histórico.

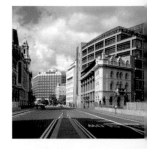

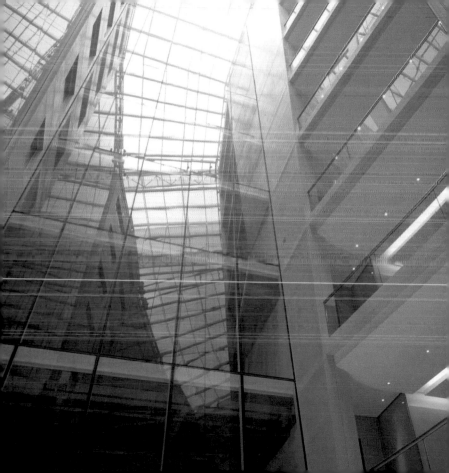

Lloyd's Register of Shipping Building

Richard Rogers Partnership
Anthony Hunt Associates

2000
71 Fenchurch Street
Broadgate EC3

www.richardrogers.co.uk

The group's new headquarters is located on a most narrow space between the partially listed neighboring buildings. Transparent service towers stand in front of the disc-like office elements. The building is livened up by the movement of the lifts, visible from far off.

Die neue Hauptverwaltung des Konzerns steht auf engstem Raum zwischen den teils denkmalgeschützten Nachbargebäuden. Vor den Stirnseiten der scheibenartigen Büroelemente stehen transparente Erschließungstürme. Die weithin sichtbare Bewegung der Aufzüge belebt das Gebäude.

La nouvelle administration centrale du groupe est située sur un espace des plus restreints entre les bâtiments voisins, en partie des monuments protégés. Devant les faces frontales des éléments de bureaux en forme de disque se trouvent les tours transparentes de viabilisation. Le mouvement visible de loin des ascenseurs donne de la vie au bâtiment.

La nueva administración central del consorcio se alza en un muy reducido espacio entre los edificios colindantes, en parte protegidos por su valor monumental. Frente a las fachadas anteriores acristaladas de los elementos de oficina se alzan unas torres transparentes. El movimiento de los ascensores, visible desde lejos, da vida al edificio.

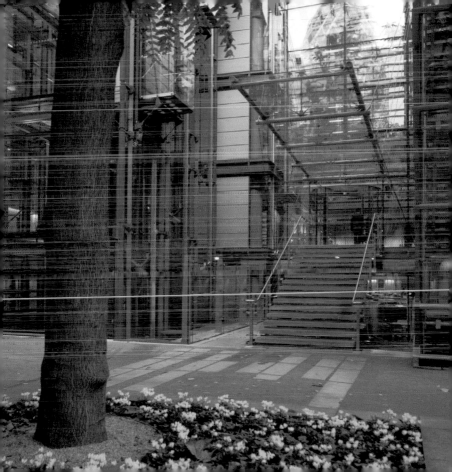

Swiss Re Headquarters

Foster and Partners
Ove Arup & Partners

2004
30 St. Mary Axe
City of London EC3

www.fosterandpartners.com

The 180-meter high Swiss Re Tower is one of the most striking new buildings in the London financial-center skyline. The office floors are turned slightly toward each other; vertical "villages" thus emerge around the interior garden. The dome offers space for a restaurant and events.

Der 180 Meter hohe Swiss Re Tower ist einer der markantesten Neubauten in der Skyline des Londoner Finanzzentrums. Die Bürogeschosse sind leicht gegeneinander verdreht, dadurch entstehen um die innenliegenden Gärten vertikale „Dörfer". Die Kuppel bietet Raum für ein Restaurant und Veranstaltungen.

La Swiss Re Tower (180 mètres de haut) est l'une des nouvelles constructions les plus marquantes dans le Skyline du centre financier londonien. Les étages de bureaux sont tournés légèrement les uns contre les autres, créant ainsi autour des jardins situés à l'intérieur des « villages » verticaux. La coupole offre de la place pour un restaurant et pour des évènements culturels et séminaires.

La Swiss Re Tower es con sus 180 metros de altura una de las nuevas construcciones más llamativas de la línea del cielo del Londres financiero. Las plantas de oficinas están ligeramente desalineadas entre sí, lo que crea unas "aldeas" verticales alrededor de los jardines interiores. La cúpula ofrece espacio para un restaurante y actos sociales.

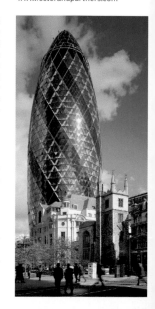

Puddledock

Alsop Architects
Buro Happold

2006
2 Puddledock
Blackfriars EC4

www.alsoparchitects.com

A new office building divided into two subdivided structures is emerging on very prominent premises on the bank of the Thames. The coloured, ceramic glistening Office-Box is accompanied by a smooth, glass covered light beam. It includes the reception desk and access to the offices.

Auf dem sehr prominenten Grundstück am Themseufer entsteht ein neues, in zwei Baukörper unterteiltes Bürogebäude. Die farbige, keramisch glänzende Office-Box wird von einem glatten, flächig verglasten Lichtbalken begleitet. Er enthält den Empfang und die Zugänge zu den Büros.

Sur ce terrain très éminent des rives de la Tamise est construit un nouvel immeuble de bureaux divisé en deux corps de bâtiments. L'Office-Box colorée en brillance céramique est accompagnée d'une colonne lumineuse lisse à surface en verre. Celleci contient l'accueil et l'accès aux bureaux.

Sobre los muy prominentes terrenos de la orilla del Támesis nace un nuevo edificio de oficinas, dividido en dos cuerpos constructivos. El colorista bloque de oficinas con brillo cerámico está acompañado de una banda luminosa lisa de completamente acristalada que alberga la recepción y los accesos a las oficinas.

The Daily Express Building

Hurley, Robertson & Associates
Evan Owen Williams, Robert Atkinson (Original Building)
Ove Arup & Partners

2000
118-120 Fleet Street
City of London EC4

www.hra.co.uk

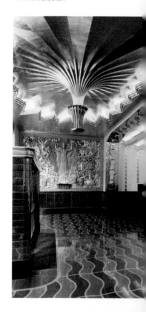

At the start of the planning of the headquarters for an investment bank, the publishing house from the thirties had already stood empty for a long time. The classical structure was extensively renovated as an integrated component of the 45,000 square meter project. Thus, it continues to exist as a living piece of the city.

Zu Beginn der Planung des Hauptquartiers für eine Investmentbank stand das Verlagshaus aus den Dreißiger Jahren bereits geraume Zeit leer. Als integrierter Bestandteil des 45.000 Quadratmeter großen Projektes wurde der Klassiker umfassend renoviert. So bleibt er auch weiterhin ein lebendiges Stück Stadt.

Au début de la planification du quartier principal d'une banque d'investissement, la maison d'édition construite dans les années 30 se trouvait vide depuis longtemps déjà. Formant partie intégrante du grand projet de 45.000 mètres carrés, le classique a été rénové de manière étendue. Il continue ainsi à rester une part vivante de la ville.

Al comenzar la planificación de las oficinas centrales de un banco de inversiones, el edificio de la editorial de los años treinta llevaba ya bastante tiempo vacío. Integrado en el gran proyecto de 45.000 metros cuadrados, este edificio clásico fue ampliamente renovado. De este modo, continúa siendo un fragmento vivo de la ciudad.

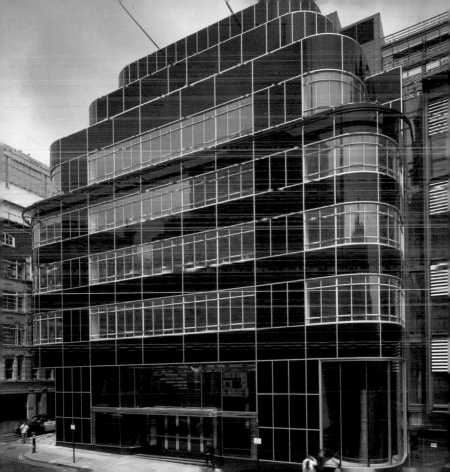

Thames Court

Kohn Pedersen Fox Associates (International) PA
Waterman Group ple

1998
1 Queenhithe
Upper Thames Street
City of London EC4

www.kpf.com

This international banking house, built on the best river location, offers optimal space proportions. The central, light-flooded atrium office presents an effective work environment for securities dealers. The individual offices are naturally lighted from two sides.

Dieses in bester Flusslage erbaute internationale Bankhaus bietet optimale Raumverhältnisse. Das zentrale, lichtdurchflutete Atrium-Büro stellt ein effektives Arbeitsumfeld für die Wertpapierhändler dar. Die Einzelbüros werden von zwei Seiten natürlich belichtet.

Cette maison banquière internationale d'excellente situation sur les rives offre des rapports d'espace optimaux. Le bureau-atrium central, très lumineux constitue un cadre de travail effectif pour les négociants en titres. Les bureaux individuels sont éclairés naturellement de deux côtés.

Este edificio de un banco internacional, levantado en una excepcional ubicación junto al río, posee óptimas condiciones de espacio. La oficina-atrio central, inundada de luz, representa un efectivo entorno de trabajo para los agentes de bolsa. Las oficinas individuales reciben iluminación natural por dos lados.

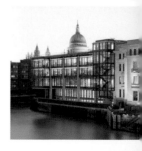

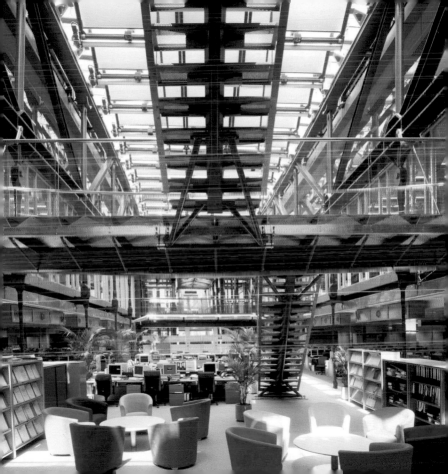

Palestra

Alsop Architects
Buro Happold

2005
197 Blackfriars Road
Southwark SE1

www.palestra-london.com
www.blackfriars-uk.com
www.alsoparchitects.com

The "Palestra" is located in the Bankside quarter south of the Thames, which is increasingly developing into one of the liveliest city districts. The building appears to be a raised "glass box". Shops and restaurants are found in the ground floor.

Die „Palestra" befindet sich im Banksideviertel südlich der Themse, das sich immer mehr zu einem der belebtesten Bezirke der Stadt entwickelt. Das Gebäude erscheint als angehobene „Glaskiste". Im Erdgeschoss befinden sich Läden und Restaurants.

La « Palestra » se trouve dans le quartier Bankside au sud de la Tamise, qui se développe de plus en plus en l'un des arrondissements les plus vivants de la ville. Le bâtiment apparaît comme « caisse en verre » surélevée. Au rez-de-chaussée se trouvent des magasins et des restaurants.

La "Palestra" se encuentra en Bankside, barrio al sur del Támesis que se está convirtiendo en una de las zonas de mayor proyección de la ciudad. El edificio aparece como una "caja de cristal" elevada. La planta baja cobija tiendas y restaurantes.

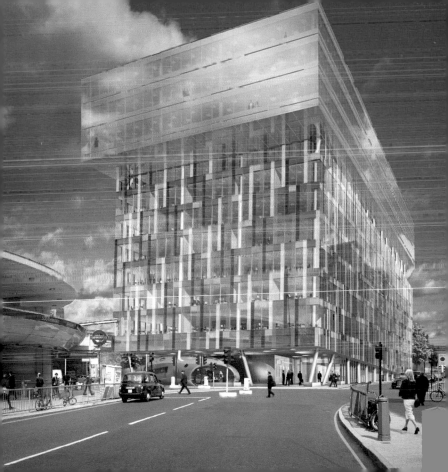

London City Hall

Foster and Partners
Ove Arup & Partners

2002
The Queen's Walk
Southwark SE1

www.london.gov.uk/gla/city_hall
www.fosterandpartners.com

The City Hall stands for democracy and accessibility. The publicly accessible ramp winds through all ten floors. From the Café in the ground floor and through the conference hall, one reaches a viewing balcony. A gallery is located at the end of the ramp, which has been given the nickname "London's living room".

Die City Hall steht für Demokratie und Zugänglichkeit. Die öffentlich zugängliche Rampe windet sich durch alle zehn Geschosse. Aus dem Cafe im Erdgeschoss gelangt man durch den Sitzungssaal zu einem Aussichtsbalkon. Am Ende der Rampe befindet sich eine Galerie, die den Beinamen „Londons Wohnzimmer" erhalten hat.

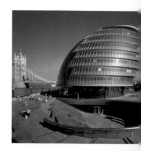

Le City Hall symbolise la démocratie et l'accessibilité. La rampe à accès ouvert au public s'élève de manière hélicoïdale à travers chacun des dix étages. Du café au rez-de-chaussée, on accède en traversant la salle de réunions à un balcon panoramique. Au bout de la rampe se trouve une galerie qui a reçu le surnom de « salon londonien ».

El City Hall representa la democracia y la accesibilidad. La rampa de acceso público serpentea por sus diez plantas. Desde el café de la planta baja se llega, a través de una sala de reuniones, a una terraza mirador. Al final de la rampa se encuentra una galería, que la ciudadanía ha bautizado como "la sala de estar de Londres".

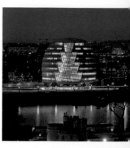

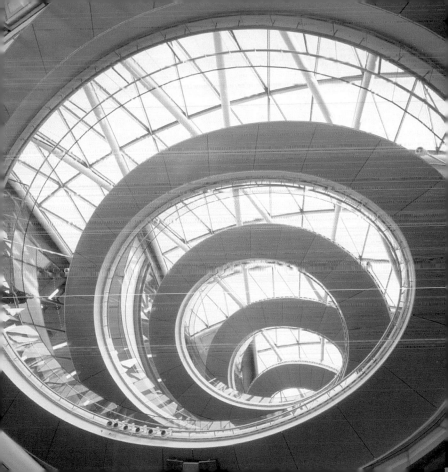

Portcullis House

Hopkins Architects
Ove Arup & Partners

2000
1 Victoria Embankment
Westminster SW1

www.portcullis-house.com
www.hopkins.co.uk

The new Michael Hopkins office building for Members of Parliament creates a structural unit together with the tube station situated under it. A glass roof vaults the central area, from which a tunnel leads to Westminster Palace. The construction made of wood and steel rests on the principal columns of the tube station.

Das neue Bürogebäude für Parlamentsabgeordnete von Michael Hopkins bildet eine bauliche Einheit mit der darunter liegenden U-Bahnstation. Der zentrale Platz, von dem aus ein Tunnel zum Westminster Palast führt, wird von einem Glasdach überspannt. Die Konstruktion aus Holz und Stahl ruht auf den Hauptstützen der U-Bahnstation.

Le nouveau bâtiment de bureaux pour les députés du parlement de Michael Hopkins constitu une unité architecturale avec la station de métro située au-dessous. La place centrale, de laquelle un tunnel mène au palais de Westminster, est recouvert d'un toit en verre. La construction en bois et en métal repose sur les contreforts principaux de la station de métro.

El nuevo edificio de oficinas para miembros del Parlamento de Michael Hopkins forma una unidad constructiva con la estación del metro sobre la cual se alza. La plaza central, desde la cual un túnel lleva al Palacio de Westminster, está cubierta por un techo de cristal. La construcción de madera y acero se asienta sobre los pilares principales de la estación inferior.

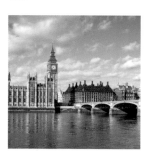

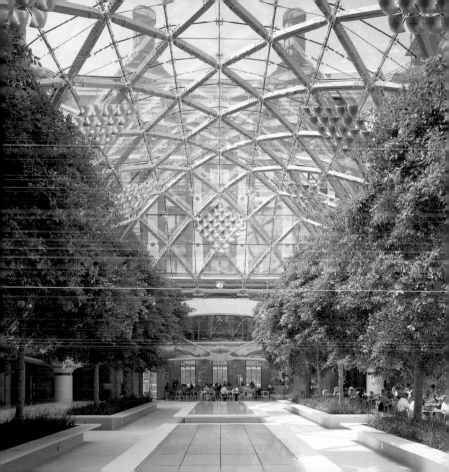

Broadwick House

Richard Rogers Partnership
Ove Arup & Partners

2002
15-17 Broadwick Street
Soho W1

www.richardrogers.co.uk

The six-storey building in the heart of Soho accommodates the Ford Motor Company design studio. Room-high glassed-in offices set themselves distinctly apart from the structurally enclosed adjoining rooms. Under the vaulted ceiling, there are two-storey ateliers with views of the London West End.

Das sechsgeschossige Gebäude im Herzen Sohos beherbergt die Design Studios der Ford Motor Company. Raumhoch verglaste Büros heben sich deutlich von den geschlossen ausgebildeten Nebenräumen ab. Unter dem gewölbten Dach gibt es zweigeschossige Ateliers mit Blick über das Londoner West End.

L'immeuble de six étages au cœur de Sohos abrite les studios de Design de la Ford Motor Company. Les bureaux à fenêtres de la hauteur de la pièce se distinguent nettement des pièces annexes à construction fermée. Sous le toit bombé sont construits des ateliers à deux étages avec vue sur la West End londonienne.

El edificio de seis plantas en el corazón del Soho alberga los Estudios de Diseño de la Ford Motor Company. Oficinas acristaladas hasta el techo se destacan claramente de las piezas auxiliares cerradas. Bajo el techo en cúpula encontramos estudios de dos plantas con vistas al West End londinense.

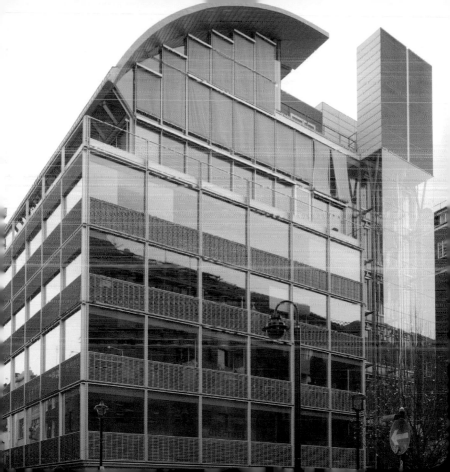

New Medical School Building

Queen Mary, University of London

Alsop Architects
Adams Kara Taylor

2004
Turner Street
Whitechapel E1

www.qmul.ac.uk
www.alsoparchitects.com

A glassed-in, three-storey pavilion is the shell of the medical faculty research facilities. Built-in units for auxiliary use are suspended over the open laboratory. A molecular-like sculpture symbolises a cell nucleus; the installation supplies information about current research results.

Ein verglaster, dreigeschossiger Pavillon ist die Hülle für Forschungseinrichtungen der medizinischen Fakultäten. Über den offenen Labors schweben Einbauten mit den Nebennutzungen. Eine molekülartige Skulptur symbolisiert einen Zellkern; die Installation informiert über aktuelle Forschungsergebnisse.

Un pavillon de trois étages en verre est l'écrin d'installations de recherches pour les facultés de médecine. Au-dessus des laboratoires ouverts se trouvent des constructions avec les utilisations secondaires. Une sculpture en forme de molécule symbolise le noyau d'une cellule, l'installation émet des informations sur les résultats actuels de la recherche.

Un pabellón acristalado de tres plantas da cobijo a las instalaciones de investigación de las facultades de medicina. Sobre los laboratorios abiertos se ubican módulos adicionales con los servicios auxiliares. Una escultura en forma de molécula simboliza el núcleo de una célula. La instalación informa sobre los resultados actuales de las investigaciones.

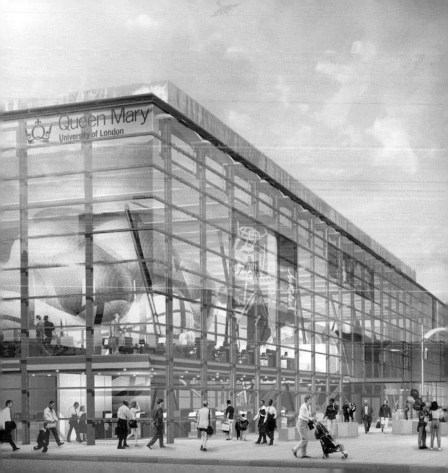

London Planetarium

Fletcher Priest Architects
SB Teitz & Partners

1995
Marylebone Road
Marylebone NW1

www.london-planetarium.com
www.fletcherpriest.com

The London Planetarium is deemed to be the most frequented planetarium in the world. A projection method was placed in the existing dome that enables one to undertake a trip through outer space. One of the most important planning tasks was effective public traffic control.

Das London Planetarium gilt als das meistbesuchte Planetarium der Welt. In der bestehenden Kuppel wurde eine Projektionstechnik eingebracht, die es ermöglicht, virtuelle Weltraumreisen zu unternehmen. Eine Hauptaufgabe der Planung war die effektive Steuerung des Publikumsverkehrs.

Le planétarium de Londres est reconnu comme celui le plus visité dans le monde. Dans la coupole existante a été inséré une technique de projections qui permet d'entreprendre des voyages virtuels dans l'espace. L'une des tâches principales de la planification était la régulation efficace de l'afflux du public.

El Planetario de Londres es el más visitado del mundo. En la cúpula ya existente se instalaron los equipos de proyección que permiten realizar viajes espaciales virtuales. Una tarea fundamental en su planificación fue la conducción eficaz del público.

bfi London IMAX Cinema

British Film Institute

Avery Associates Architects
Anthony Hunt Associates Ltd.

1999
1 Charlie Chaplin Walk
South Bank SE1

www.bfi.org.uk
www.avery-architects.co.uk

The IMAX is located on an island surrounded by heavy traffic that leads to a pedestrian tunnel. It is shrouded by a glassed gallery that wards off noise from the street but is also meant to convey the building content. An artist's competition for designing it is announced every year.

Das IMAX steht auf einer von dichtem Verkehr umflossenen Insel, zu der ein Fußgängertunnel führt. Es hüllt sich in eine gläserne Galerie, die den Straßenlärm abhalten, aber auch den Gebäudeinhalt vermitteln soll. Für ihre Gestaltung wird alljährlich ein Künstlerwettbewerb ausgeschrieben.

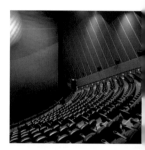

L'IMAX se trouve sur une île entourée d'un trafic dense et à laquelle mène un tunnel pour piétons. Il s'habille d'une galerie de verre qui retient le bruit de la circulation, mais doit aussi véhiculer le contenu de l'édifice. Sa décoration fait tous les ans l'objet d'un concours d'artistes.

El IMAX se alza en una isla rodeada de denso tráfico, comunicada a través de un túnel peatonal. Está recubierta por una galería de cristal que la aísla del ruido del tráfico y que debe al tiempo transmitir su contenido interior. Para su conformación se convoca cada año un concurso de artistas.

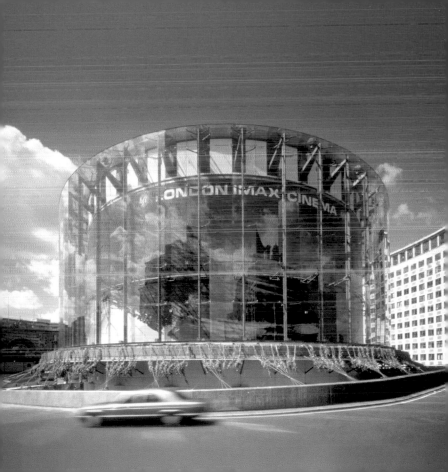

Tate Modern

Herzog & de Meuron
Sir Giles Gilbert Scott (Original Building)
Ove Arup & Partners

2000
Bankside
Southwark SE1

www.tate.org.uk

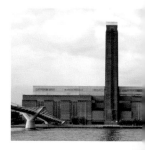

The Bankside Power Station in Southwark, unused for a long time, now accommodates the Tate Modern. The powerful industrial architecture impresses through its de-cored turbine hall in which a suspended glass box floats. The architects have transformed the former "cathedral of energy" into a gallery of light.

Das zuvor lange Zeit ungenutzte Bankside Kraftwerk in Southwark beherbergt heute die Tate Modern. Die kraftvolle Industriearchitektur beeindruckt mit ihrer entkernten Turbinenhalle, in der eine abgehängte Glasbox schwebt. Die Architekten haben die ehemalige „Kathedrale der Energie" in eine Galerie des Lichts umgewandelt.

La centrale électrique Bankside restée longtemps inutilisée abrite aujourd'hui la Tate Modern. La puissance architecture industrielle impressionne par sa halle à turbines sans noyau, dans laquelle pend une boîte en verre surbaissée. Les architectes ont transformé l'ancienne « Cathédrale de l'énergie » en une galerie de la lumière.

La durante largo tiempo inutilizada central energética de Bankside en Southwark alberga hoy la Tate Modern. La poderosa arquitectura industrial impresiona con su sala de turbinas vaciada, donde queda suspendida una caja de cristal. Los arquitectos han convertido la antigua "Catedral de la energía" en una galería de la luz.

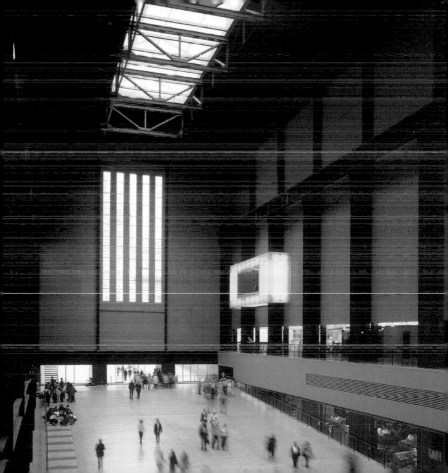

The National
Maritime Museum

Rick Mather Architects, Building Design Partnership
Building Design Partnership

1999
Park Row
Greenwich SE10

www.nmm.ac.uk
www.rickmather.com
www.bdp.co.uk

A free-span glass roof covers the inner yard between the famous Queens House and the two flanking building wings. Even very large exhibits can be displayed in the newly additionally acquired exhibition space.

Ein freispannendes Glasdach überdeckt den Innenhof zwischen dem berühmten Queens House und den beiden flankierenden Gebäudeflügeln. In dem neu dazugewonnenen Ausstellungsraum können jetzt auch sehr große Exponate ausgestellt werden.

Un toit en verre indépendant couvre la cour intérieure entre la célèbre Queens House et les deux ailes de bâtiment qui flanquent celle-ci. Dans le nouvel espace d'exposition ainsi créé, il est possible d'exposer également de très grands objets d'exposition.

Un techo de cristal de sujeción por colgadura recubre el patio interior entre la famosa Queens House y las dos alas del edificio. Se ha ganado así un nuevo espacio exposiciones con capacidad para objetos de exposición de grandes dimensiones.

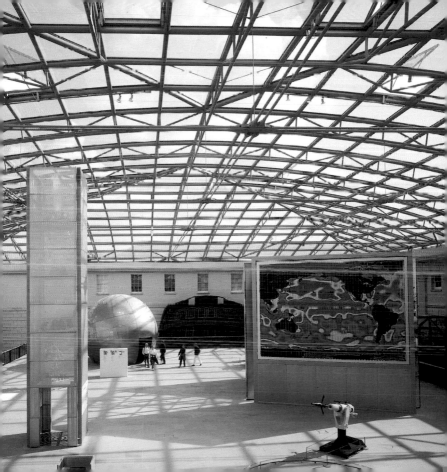

Goldsmiths College of Art

Alsop Architects
Adams Kara Taylor

2004
New Cross Road, St James's
New Cross SE14

www.goldsmiths.ac.uk
www.alsoparchitects.com

The optical mass of the seven-storey box is broken open by a level of silver-coloured reliefs. During the day, they draw their shadows on the façade; a light installation is to twinkle over it at night. The two-storied recessed area, surrounded by intricate metal structures, defines the roof terrace.

Die optische Masse der sieben-geschossigen Box wird durch eine Ebene silberfarbener Reliefs aufgebrochen. Tagsüber zeichnen sie ihre Schatten auf die Fassade, nachts soll eine Lichtinstallation darüber flimmern. Der zweigeschossig ausgesparte, von verschlungenen Metallstrukturen umhüllte Bereich, definiert die Dachterrasse.

La masse optique de la boîte de sept étages est interrompue par une zone de reliefs de couleur argentée. Le jour, ceux-ci dessinent leur ombre sur la façade, la nuit, c'est une installation de lumière qui les fait briller. La zone de deux étages embrassée par des structures métalliques et qui se détache, définit la terrasse de toit.

La masa visual del bloque de siete plantas se trunca por un plano de relieves en color plateado. Durante el día, sus sombras inciden sobre la fachada, por la noche se prevé que una instalación luminosa produzca efectos brillantes. El área entallada de dos plantas, recubierta de estructuras metálicas entrelazadas, define la azotea.

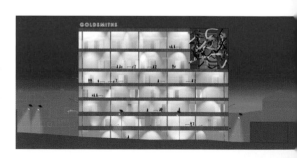

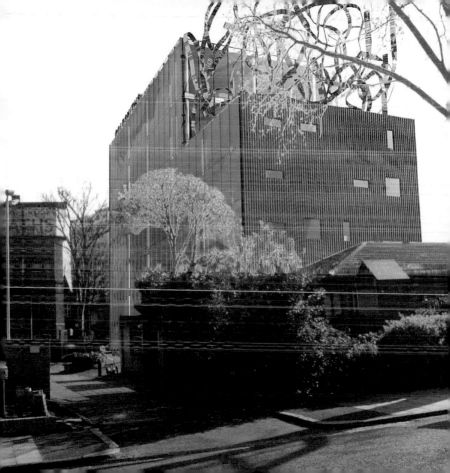

Peckham Library

Alsop Architects
Adams Kara Taylor

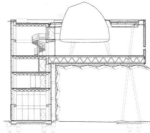

2000
122 Peckham Hill Street
Peckham SE15

www.alsoparchitects.com

The erected angle sits on only a few inclined supports. One intuitively finds the entrance under the hanging arcade. A lift conveys the visitors into the reading room suspended high over the plaza. Body and mind should proverbially rise.

Der aufgestellte Winkel ruht auf nur wenigen, geneigten Stützen. Unter den hängenden Arkaden findet man intuitiv den Eingang. Ein Aufzug befördert den Besucher in den weit über dem Platz schwebenden Leseraum. Körper und Geist sollen sprichwörtlich abheben.

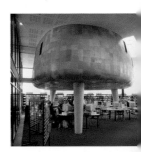

L'angle posé repose seulement sur peu de contreforts inclinés seulement. Sous les arcades en suspension, on trouve intuitivement l'entrée. Un ascenseur conduit les visiteurs dans l'espace de lecture suspendu loin au dessus de la place. L'esprit et le corps doivent s'élever au sens propre du terme.

La esquina erigida se apoya en unos pocos soportes inclinados. Debajo de las arcadas colgantes se encuentra intuitivamente la entrada. Un ascensor transporta al visitante a la sala de lectura, situada a buena altura. Se pretende elevar cuerpo y espíritu, literalmente.

Laban Dance Centre

Herzog & de Meuron
Whitby Bird & Partners (WB&P)

2002
Creekside
Deptford SE8

www.laban.org

The façades of the Dance Centre are composed out of transparent and translucent glass panels depending on whether the room behind needs a view. The dancers' magical silhouettes, which fall onto the matt glass surface from within, are an active part of the architectural identity.

Die Fassaden des Dance Centre bestehen aus transparenten und transluzenten Glaspaneelen, je nach dem, ob der dahinterliegende Raum Ausblick benötigt. Die magischen Schattenbilder der Tänzer, welche von innen auf die matten Glasoberflächen fallen, sind aktiver Teil der architektonischen Identität.

Les façades du Dance Centre sont composées de panneaux en verre transparents et translucides, en fonction de la vue nécessitée par la pièce se trouvant derrière ceux-ci. Les images magiques des danseurs projetées de l'intérieur sur les surfaces en verre mates forment une partie active de l'identité architectonique.

Las fachadas del Dance Centre se componen de paneles de cristal transparentes y traslúcidos, dependiendo de la necesidad o no de facilitar la vista a la correspondiente sala. Las formas mágicas que adquieren las sombras de los bailarines sobre las superficies de cristal mate son parte activa de la personalidad arquitectónica del edificio.

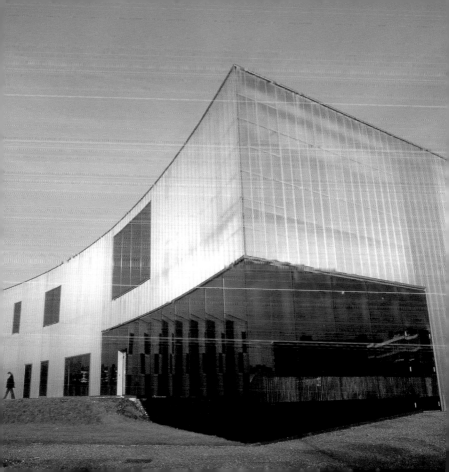

Extension to the Victoria & Albert Museum

Daniel Libeskind
Cecil Balmond, Ove Arup & Partners

2006
Cromwell Road
South Kensington SW7

www.vam.ac.uk
www.daniel-libeskind.com

Daniel Libeskinds "Spiral" is new museum entrance structure, which is still being planned. Along with the new main staircase, the dynamic building-envelope encloses a series of galleries that are equipped with the most up-to-date technology. One goal of the planner is to convey the visitors the depth of the collections in a playful manner.

Daniel Libeskinds „Spiral" ist das noch in Planung befindliche, neue Zugangsbauwerk des Museums. Die dynamische Gebäudehülle fasst, neben dem neuen Haupttreppenhaus, eine Reihe von Galerien, die mit modernster Technik ausgestattet sind. Ein Ziel der Planer ist, den Besuchern spielerisch die Tiefe der Sammlungen zu vermitteln.

La « spirale » de Daniel Libeskind est le nouvel édifice d'accès au musée qui se trouve encore en planification. Outre la nouvelle cage d'escalier, l'écrin dynamique de la construction touche une série de galeries équipées des techniques les plus modernes. Un objectif des auteurs des plans est de transmettre de manière ludique aux visiteurs la profondeur des collections.

La "Espiral" de Daniel Libeskind es la nueva edificación de acceso al museo y se encuentra aún en fase de planificación. La dinámica envoltura del edificio abarca, además de la nueva escalera principal, una serie de galerías equipadas con la técnica más moderna. Uno de los objetivos de los proyectistas es comunicar a los visitantes de forma lúdica la profundidad de las colecciones.

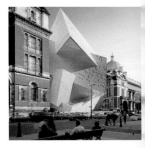

70

Hampden Gurney Primary School

Building Design Partnership

2002
13 Nutford Place
Marylebone W1

www.bdp.co.uk

As the school garden was too small to be used as a play-ground, an open area was created on each floor. Here, the children can play in the fresh air. A clear spatial separation from the instructional areas prevents disturbances.

Da der Garten der Schule als Spielplatz zu klein war, wurde auf jedem Geschoss ein offener Raum geschaffen. Hier können die Kinder an der frischen Luft spielen. Eine klare räumliche Trennung vom Unterrichtsbereich baut Störungen vor.

Comme le jardin de l'école était trop petit comme aire de jeux, un espace ouvert a été créé à chaque étage. C'est là que les enfants peuvent jouer à l'air frais. Une séparation claire de la zone de cours dans l'espace prévient tous dérangements.

Debido a que el jardín de la escuela era demasiado pequeño como patio de recreo, se ha creado un espacio abierto en cada planta donde los niños pueden jugar al aire libre. Una clara separación espacial de la zona lectiva evita las molestias.

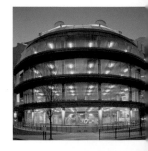

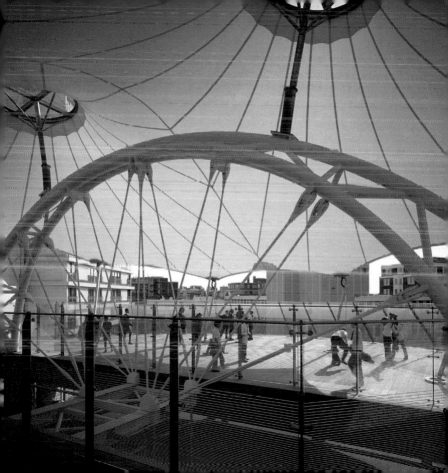

The Great Court at the British Museum

Foster and Partners
Buro Happold

2000
Great Russell Street
Bloomsbury WC1

www.thebritishmuseum.ac.uk
www.fosterandpartners.com

The glass roof spans the entire inner courtyard of the British Museum. The construction is carried out very gracefully in order to let the roof cladding appear as light and transparent as possible. The museum's public reading room is found in the round building in the Great Court.

Das Glasdach überspannt den gesamten Innenhof des British Museum. Die Konstruktion ist sehr zierlich ausgeführt, um die Dachhaut möglichst leicht und transparent erscheinen zu lassen. Im runden Gebäude auf dem Great Court befindet sich der öffentliche Lesesaal des Museums.

Le toit en verre recouvre toute la cour intérieure du British Museum. La construction est de forme très fine pour faire apparaître l'écorce du toit le plus léger et le plus transparent possible. Dans le bâtiment rond sur le Great Court se trouve la salle de lecture publique du musée.

El techo de cristal recubre todo el patio interior del British Museum. La construcción se ha realizado con la máxima gracilidad para dotar a la cubierta de un aspecto lo más ligero y transparente posible. El edificio circular en el Great Court alberga la sala pública de lectura del museo.

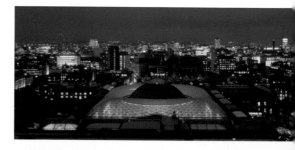

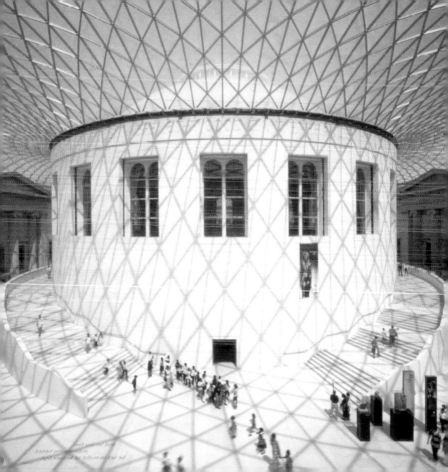

Plashet School Footbridge

Birds Portchmouth Russum Architects
Techniker

2000
Plashet Grove
East Ham E6

www.birdsportchmouthrussum.com

The school needed a covered crossing between two buildings that stand across from each other on a busy street. The footbridge depicts an arch in order to adapt to their differing alignments. A meeting point for pedestrians is found halfway.

Die Schule benötigte einen gedeckten Übergang zwischen zwei Gebäuden, die sich an einer belebten Straße gegenüberliegen. Um sich an deren unterschiedliche Ausrichtung anzupassen, beschreibt der Steg einen Bogen. Auf halbem Weg ist ein Treffpunkt für die Passanten.

L'école nécessitait un passage couvert entre deux bâtiments qui se trouvaient face à face l'un de l'autre sur une rue animée. Pour s'adapter à leurs architectures différentes, la passerelle décrit un arc. A mi-chemin se trouve un point de rencontre pour les passants.

La escuela necesitaba un paso cubierto entre dos edificios situados a ambos lados de una concurrida calle. Para adaptarse a sus diferentes orientaciones, la pasarela describe un arco. A medio camino se ubica un punto de encuentro para los transeúntes.

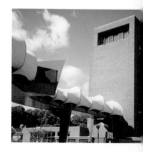

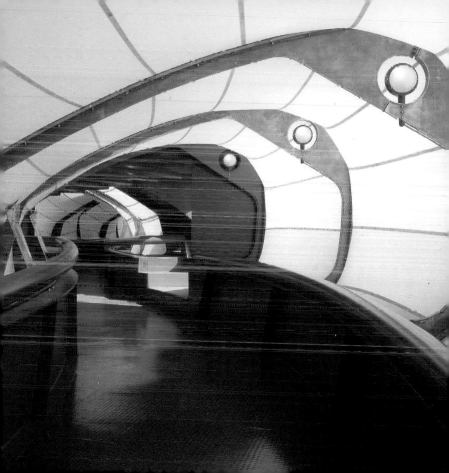

Floating Bridge

Future Systems
Anthony Hunt Associates

1996
West India Quay
Canary Wharf E14

www.future-systems.com

The slim, brightly coloured pedestrian bridge by Future Systems resembles a shining insect walking over the water. By using buoys, foundation work underneath the water level was able to be done without.

Die schlanke, knallbunte Fußgängerbrücke von Future Systems ähnelt einem leuchtenden Insekt, das über das Wasser läuft. Durch die Verwendung von Schwimmkörpern konnte auf Gründungsarbeiten unterhalb des Wasserspiegels verzichtet werden.

Le pont pour piétons, élancé et de couleurs vives de Future Systems ressemble à un insecte lumineux qui passe sur l'eau. Grâce à l'utilisation de corps flottant, il a pu être renoncé à des travaux de fondations au-dessous du niveau de l'eau.

La delgada y colorista pasarela peatonal de Future Systems semeja un insecto luminoso desplazándose sobre el agua. El empleo de cuerpos flotantes permitió evitar trabajos de cimentación por debajo del nivel del agua.

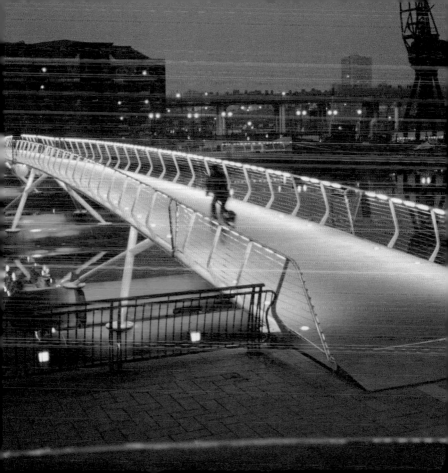

Heron Quays

Alsop Architects
WS Atkins Limited

2003
Heron Quays
Canary Wharf E14

www.alsoparchitects.com

The continuing development of the quarter caused the reconstruction of the stop to become necessary. Due to the lack of space, it was very expensive to accommodate a supporting structure autonomous from the neighboring building. A curved soundproofing shell that suppresses noise from the trains hangs under the rails.

Die voranschreitende Entwicklung des Quartiers machte den Neubau der Haltestelle notwendig. Wegen des beengten Raumes war es sehr aufwändig, ein von der Nachbarbebauung autonomes Tragwerk unterzubringen. Unter den Schienen hängt eine gebogene Schallschutzschale, die den Zuglärm zurückhält.

Le développement en progression du quartier a rendu nécessaire la construction d'une nouvelle station. En raison de l'espace restreint, il a été très difficile d'intégrer une fondation autonome de la construction voisine. Sous les rails se trouve une coque d'insonorisation arrondie qui retient le bruit des trains.

El progresivo desarrollo del barrio hacía necesario construir una nueva estación. A causa del espacio reducido resultaba muy costoso instalar una estructura portante independiente de las edificaciones contiguas. Bajo los rieles pende una cubierta insonorizadora arqueada que aísla el ruido de los trenes.

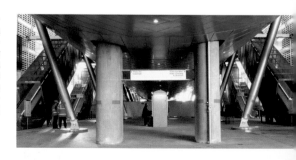

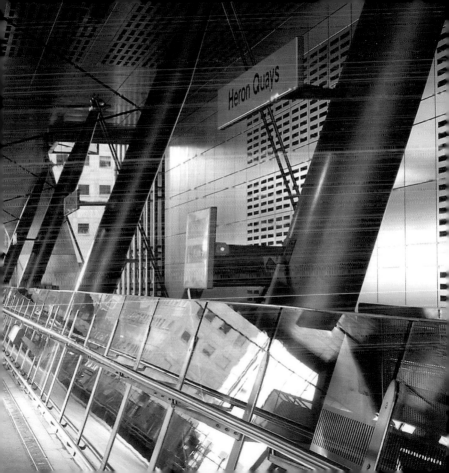

Stratford Regional Station

Wilkinson Eyre Architects
Hyder Consulting Limited

1999
45 Gibbins Road
Stratford E15

www.wilkinsoneyre.com

Local and long distance traffic coincide at the Jubilee Line extension terminal. The two-storey Stratford Station Terminal, which reminds one of an airport, marks the entrance to the traffic junction. A pleasantly airy, light-flooded entrance hall is situated in the elegant sweeping building.

Am Endpunkt der Jubilee Line Extension treffen Nah- und Fernverkehr zusammen. Das zweigeschossige, an einen Flughafen erinnernde Stratford Station Terminal markiert den Zugang des Verkehrsknotenpunktes. In dem elegant geschwungene Gebäude befindet sich die angenehm luftige, lichtdurchflutete Eingangshalle.

Au point final de la Jubilee Line Extension se rencontrent le trafic de proximité et celui des grandes lignes. Le terminal Stratford Station à deux étages, rappelant un aéroport marque l'accès de la gare routière. Dans le bâtiment incurvé de manière élégante se trouve le hall d'entrée de construction légère et très lumineuse.

Al final de la ampliación de la Jubilee Line se unen el tráfico de cercanías y el de largas distancias. La estación terminal de Stratford, que con sus dos pisos recuerda a un aeropuerto, marca el acceso del nudo de comunicaciones. El elegante edificio alberga el agradablemente ventilado e inundado de luz hall de entrada.

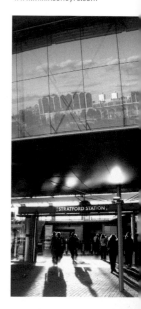

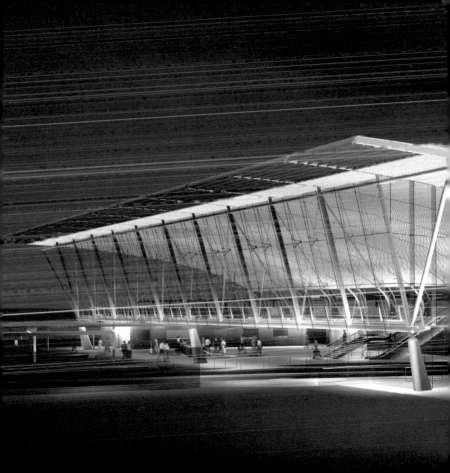

Canada Water Bus Interchange

Eva Jiricna Architects
Benaim Works JV

1999
Surrey Quays Road
Rotherhithe SE16

www.ejal.com

In the frame of the Jubilee Line extension, a bus junction was developed on the Canada Water tube station. A 100-meter long roof resting on five supports spans the entire arrangement. The canopy and the wing edges were glassed to improve the lighting of the stop.

Im Rahmen der Jubilee Line Erweiterung wurde an der U-Bahn Station Canada Water ein Busknotenpunkt entwickelt. Ein 100 Meter langes, auf fünf Stützen ruhendes Dach überspannt die gesamte Anlage. Das Rückgrat und die Flügelränder wurden zur besseren Belichtung der Haltestellen verglast.

Dans le cadre de l'extension de la Jubilee Line, une gare routière a été construite à proximité directe de la station de métro Canada Water. Un toit de 100 mètres de long, reposant sur cinq contreforts recouvre l'ensemble de l'installation. L'arrête arrière saillante et les bordures d'ailes sont en verre pour un meilleur éclairage des stations.

En el marco de la ampliación de la Jubilee Line se ha desarrollado un nudo de autobuses en la estación del metro de Canada - Water. Un techo de 100 metros de largo apoyado en cinco soportes recubre toda la instalación. La columna vertebral y los flancos de las alas están acristalados para una mejor iluminación de las paradas.

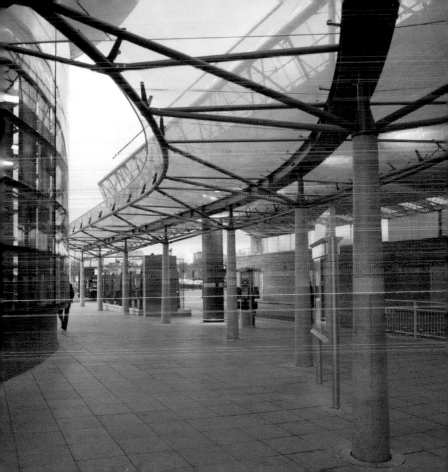

Jubilee Line Extension

38. **West Ham Station**
van Heyningen
and Haward Architects

1999

www.vhh.co.uk

The Jubilee Line Extension connects London's center with the east. In the tide of "millennium architecture", the six new and five modernised tube stations are conceived as ultramodern traffic structures and architectural culminations. All eleven structures are conceived as airy, and where possible, as naturally lighted, easily comprehensible areas.

Die Jubilee Line Extension verbindet Londons Zentrum mit dem Osten. Die sechs neuen und fünf modernisierten U-Bahn-stationen sind im Zuge der „Mil-lenium-Architektur" als ultra-moderne Verkehrsbauten und architektonische Höhepunkte konzipiert. Alle elf Bauwerke sind als luftige und, wo möglich, als natürlich belichtete, leicht verständliche Räume konzipiert.

La Jubilee Line Extension relie le centre de Londres avec l'est de la ville. Les six nouvelles et les cinq stations de métro modernisées sont conçues dans l'esprit de l'architecture Millénium comme constructions de transports ultramodernes. Chacune des onze constructions est de conception légère, conçue comme espace éclairé naturellement et facilement compréhensible.

La ampliación de la Jubilee Line conecta el centro de Londres con el este. Las seis estaciones de metro nuevas y cinco modernizadas están concebidas según el esquema de la "Arquitectura del Milenio" como infraestructuras de transporte ultramodernas. Las once obras están diseñadas como espacios bien aireados y naturalmente iluminados y fácilmente inteligibles.

86

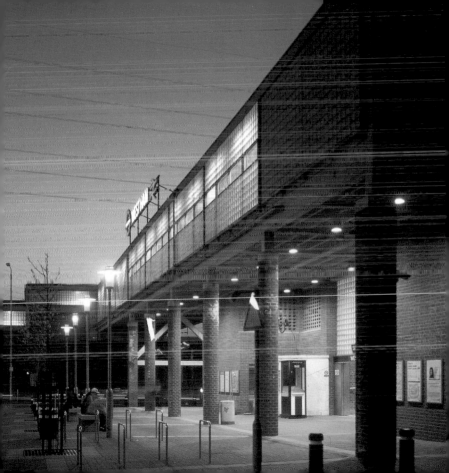

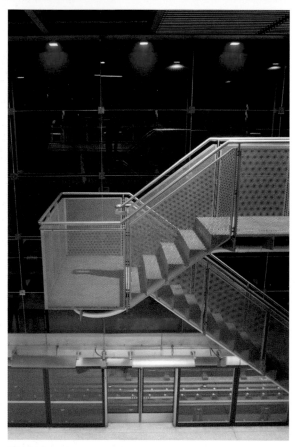

39. **North Greenwich Station**
Alsop Architects

2000

www.alsoparchitects.com

40. **Canary Wharf Station**
Foster and Partners

1999

www.fosterandpartners.com

41. London Bridge Station
JLE Architects, Weston Williamson

2000

www.westonwilliamson.com

42. Southwark Station
MacCormac Jamieson Prichard

1999

www.mjparchitects.co.uk

International Terminal Waterloo

Grimshaw
Anthony Hunt Associates

1993
Waterloo Station
Southwark SE1

www.grimshaw-architects.com

The Waterloo International Terminal is one of the longest train stations in the world. The 400-meter long platforms are suspended two floors over the parking area. The roof completely covers the Eurostar trains on the five new tracks and adapts itself to both the curves and the changing platform widths.

Das Waterloo International Terminal ist einer der längsten Bahnhöfe der Welt. Die 400 Meter langen Bahnsteige schweben zwei Geschosse über dem Parkplatz. Das Dach überdeckt die Eurostarzüge auf den fünf neuen Gleise vollständig und passt sich sowohl an die Kurve, als auch an die sich verändernde Breite der Bahnsteige an.

Le terminal international de Waterloo est l'une des plus longues gares du monde. Les quais de 400 mètres de long flottent deux étages au-dessus du parking. Le toit couvre complètement les trains Eurostar sur les cinq nouvelles voies et s'adapte aussi bien aux courbes qu'à la largeur variable des quais.

La terminal internacional de Waterloo es una de las estaciones más largas del mundo. Sus andenes de 400 metros de longitud se levantan dos plantas por encima del aparcamiento. El techo cubre por completo los trenes Eurostar en los cinco nuevos andenes adecuándose tanto a la curva como a la anchura cambiante de los andenes.

The Royal Victoria Dock Bridge

Lifschutz Davidson
Techniker

1998
Royal Victoria Dock, Silvertown Wa...
Canning Town E16

www.lifschutzdavidson.com

This elevated pedestrian bridge has an extremely airy effect despite its free span-width of over 120 meters. The spatial support structure, raised by 15 meters, is derived from the idea of a bridge crane. Due to heavy shipping traffic, this design appeared more sensible here than a bascule bridge.

Diese aufgestelzte Fußgängerbrücke wirkt extrem leicht und das trotz ihrer freien Spannweite von über 120 Metern. Das um 15 Meter angehobene räumliche Tragwerk ist von der Idee eines Brückenkrans abgeleitet. Wegen des starken Schiffsverkehrs erschien diese Konstruktion hier sinnvoller als eine Klappbrücke.

Ce pont pour piétons sur pieux élevés donne une impression extrêmement légère et ce malgré sa portée libre de plus de 120 mètres. L'ossature porteuse dans l'espace levée de 15 mètres est dérivée de l'idée d'une grue à ponts. En raison de l'important trafic fluvial, cette construction semblait ici plus judicieuse qu'un pont basculant.

Esta pasarela peatonal sobreelevada destaca por su ligereza, a pesar de su abertura de más de 120 metros. La idea de la estructura portante elevada 15 metros está sacada del principio de una grúa de pórtico. A causa del intenso tráfico de buques, esta construcción fue considerada más adecuada que un puente levadizo.

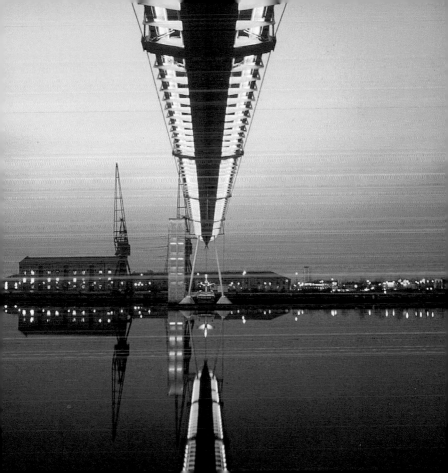

Royal Victoria Square

Patel Taylor / EDAW
Aspen Burrow Crocker

2000
Royal Victoria Square
Canning Town E16

The public plaza is meant to reflect and preserve the characteristics of the surroundings. The linear suspended roofing defines the green parking space and brings the listed warehouse into relation with the docks. The black, monolithic concrete pier supports this effect.

Der öffentliche Platz soll die Besonderheiten der Umgebung reflektieren und konservieren. Die linearen, schwebenden Überdachungen definieren den grünen Parkraum und bringen das denkmalgeschützte Lagerhaus zu den Docks in Bezug. Der schwarze, monolithische Betonpier unterstützt diesen Effekt.

La place publique doit refléter et conserver les particularités de l'environnement. Les toitures linéaires et flottantes définissent l'espace de parc vert tout en mettant en rapport avec les docks le monument protégé qu'est le bâtiment d'entreposage. L'appontement en béton monolithique noir souligne cet effet.

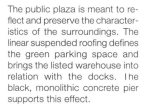

Se pretende que la plaza pública refleje y conserve las particularidades de su entorno. Los tejados lineales y elevados definen el aparcamiento verde y evocan el almacén con los Docks, protegidos por su valor monumental. El negro y monolítico muelle de hormigón acentúa este efecto.

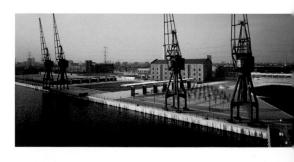

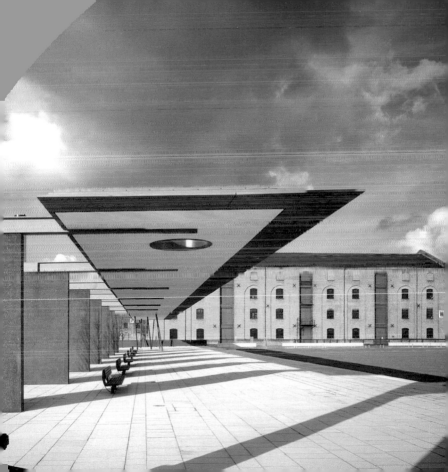

Blackfriars Station

Alsop Architects
Ove Arup & Partners

2004-2005
Queen Victoria Street
Blackfriars EC4

www.alsoparchitects.com

The planned Blackfriars Train Station is to be built on a railway bridge from the 19th century. It is indispensable for a better connection of the northern boroughs with those in the south. A light, glassed-in canopy over the platform preserves the view of St Paul's Cathedral.

Der geplante Blackfriars Bahnhof soll auf einer Eisenbahnbrücke aus dem 19. Jahrhundert entstehen. Für eine bessere Verbindung der nördlichen Boroughs mit denen im Süden ist er unverzichtbar. Ein leichter, gläserner Himmel über den Bahnsteigen bewahrt den Blick auf die St Paul's Cathedral.

La gare de Blackfriars en planification doit être construite sur un pont de chemins de fers du 19 siècle. Elle est indispensable une meilleure correspondance des Boroughs du nord avec ce los du sud. Une toiture légère e verre sur les quais garde la vu sur la cathédrale de St Paul.

El proyecto de la estación de Blackfriars contempla su construcción sobre un puente ferroviario del siglo XIX. Resulta imprescindible para una mejor conexión de los distritos del norte con los del sur. Un ligero techo de cristal sobre los andenes permite la visión de la catedral de St Paul.

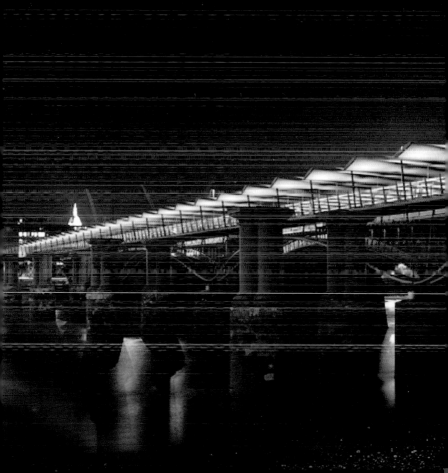

Paddington Station

Grimshaw
WS Atkins

1999
London Street
Paddington W2

www.grimshaw-architects.com

Paddington Station, traditionally the western gate to London, is one of the most significant Victorian train stations in Great Britain. In the course of reconstruction, all provisional installations were removed. The most marked change is the integrated check-in zone for Heathrow Airport and its surrounding gastronomy.

Paddington Station, traditionell die westliche Pforte Londons, ist einer der bedeutendsten viktorianischen Bahnhöfe Großbritanniens. Im Zuge der Sanierung wurden sämtliche provisorischen Einbauten entfernt. Markanteste Neuerung ist die integrierte Check-in Zone für den Heathrow Airport und die sie umgebende Gastronomie.

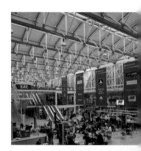

La Paddington Station, traditionnellement la porte ouest de Londres est l'une des gares victoriennes les plus importantes en Grande-Bretagne. Au fil de la rénovation, toutes les constructions provisoires ont été enlevées, l'innovation la plus marquante est constituée par la zone d'enregistrement intégrée pour l'aéroport d'Heathrow et la gastronomie environnant celle-ci.

La estación de Paddington, tradicional Puerta Oeste de Londres, es una de las más notables estaciones victorianas de Gran Bretaña. Los trabajos de saneamiento incluyeron la retirada de todos los módulos provisionales; la novedad más llamativa es la zona de facturación integrada para el aeropuerto de Heathrow y las instalaciones de restauración de su entorno.

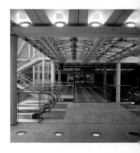

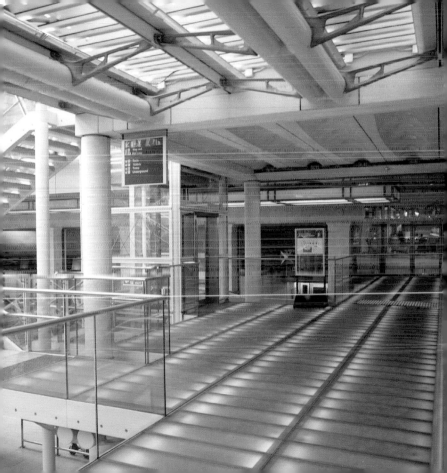

British Airways London Eye

Marks Barfield Architects
Ove Arup & Partners

1999
Jubilee Gardens, York Road
South Bank SE1

www.londoneye.com
www.marksbarfield.com

The BA London Eye, with its 135 meters, is deemed to be the highest Ferris wheel in the world. As on a bicycle, the 64 spokes are mounted from the rim to the hub. The round passenger capsules do not hang as in a traditional Ferris wheels but are attached from the outside to the main wheel rim using two ring bearings.

Das BA London Eye gilt mit 135 Metern als das höchste Riesenrad der Welt. Die 64 Speichen sind, wie bei einem Fahrrad, von der Felge zur Nabe gespannt. Runde Passagierkapseln hängen nicht wie bei traditionellen Riesenrädern, sondern sind mit zwei Befestigungsringen von außen an der Hauptfelge befestigt.

Le BA London Eye est considéré avec ses 135 mètres comme la roue géante la plus haute du monde. Les 64 rayons sont tendus, comme pour un vélo, de la jante au moyeu. Les loges de passagers rondes ne sont pas suspendues comme sur les roues géantes traditionnelles mais fixées de l'extérieur à la jante principale par deux anneaux de fixation.

La BA London Eye está considerada con sus 135 metros la noria más alta del mundo. Sus 64 radios están tensados como los de una bicicleta, de la llanta al cubo. Las cápsulas redondas para los pasajeros no cuelgan como en las norias tradicionales, sino que están fijadas por fuera a la llanta principal con dos anillos de sujeción.

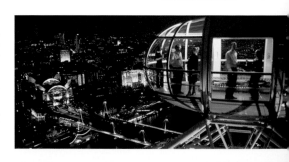

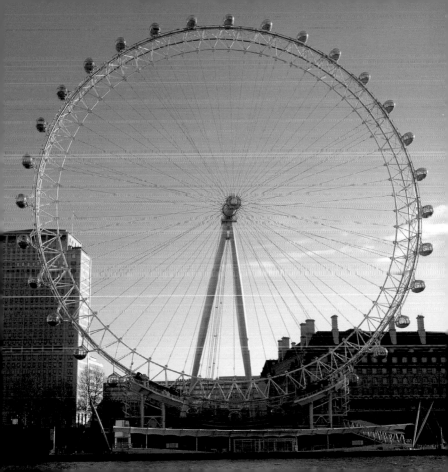

Millennium Bridge

Foster and Partners / Sir Anthony Caro
Ove Arup and Partners

2002
Bankside, Queen Victoria Street
Southwark SE1

www.fosterandpartners.com

The Millenium Bridge connects the Tate Modern Gallery with the City of London. The flat 350-meter long pedestrian bridge over the river stretches like a rope. End bearings in "Y" frames and four cables per side stabilise the construction. Subsequently installed dampers absorb sway vibrations.

Die Millenium Bridge verbindet die Tate Modern Galerie mit der City of London. Wie ein Seil spannt sich die flache, 350 Meter lange Fußgängerbrücke über den Fluss. Auflager in Y–Form und vier Zugbänder je Seite stabilisieren die Konstruktion. Nachträglich eingebaute Dämpferelemente absorbieren die auftretenden Schwingungen.

Le Millenium Bridge relie la Tate Modern Galerie avec la Cité de Londres. Le pont piétonnier plat de 350 mètres de long s'étend sur le fleuve comme un câble. Des semelles de bétons en forme de Y et quatre bandes de tension par côté stabilisent la construction. Des éléments d'amortissement montés ultérieurement absorbent les trépidations qui surviennent.

El Puente del Milenio conecta la Tate Modern Galerie con la City londinense. Este puente peatonal plano de 350 metros de longitud se tensa como un cable sobre el río. Sus apoyos en forma de Y estabilizan la construcción con ayuda de los cuatro tirantes por lado. Los elementos de amortiguación incorporados a posteriori absorben las vibraciones aparecidas.

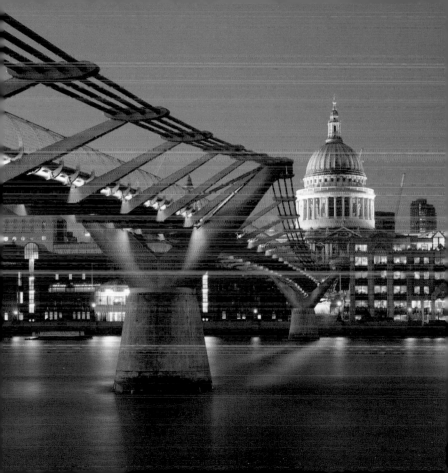

to stay . hotels

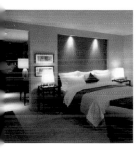
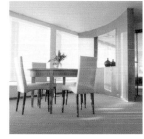
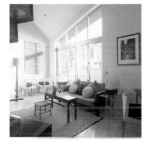

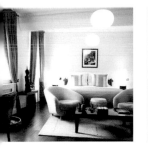
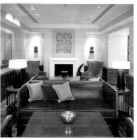
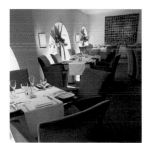

Four Seasons Hotel Canary Wharf

United Designers + Renton, Howard, Wood, Levin Partnership
Bovis Lend Lease

1999
46 Westferry Circus
Canary Wharf E14

www.fourseasons.com/canarywharf
www.united-designers.com
www.rhwl.com

The building with the panoramic view of the Thames and the skyline is found in the middle of the new Canary Wharf office city. Opposed to the otherwise quite conservative design of the hotel group, the lobby, restaurants, rooms, and suites impress rather through noble simplicity.

Das Haus mit dem Panoramablick auf die Themse und die Skyline befindet sich inmitten der neuen Bürostadt Canary Wharf. Im Unterschied zu der sonst eher konservativen Gestaltung der Hotelgruppe, fallen Lobby, Restaurants, Zimmer und Suiten hier eher durch noble Schlichtheit auf.

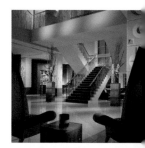

La maison avec vue panoramique sur la Tamise et la Skyline se trouve au centre de la nouvelle cité de bureaux Canary Wharf. A la différence de l'organisation sinon plutôt conservatrice du groupe hôtelier, le hall d'entrée, les restaurants, chambres et suites attirent ici l'attention par une sobriété noble.

El edificio, con vista panorámica al Támesis y a la línea del cielo londinense, se halla en el centro de la nueva ciudad de oficinas Canary Wharf. En contraste con la generalmente conservadora decoración del grupo hotelero, el lobby, los restaurantes, las habitaciones y suites destacan por su elegante sencillez.

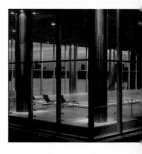

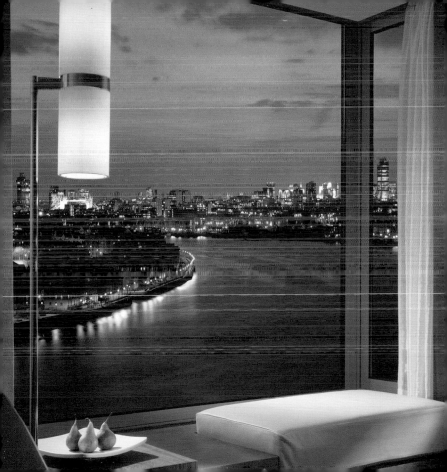

Great Eastern Hotel

Conran & Partners

2000
Liverpool Street
Broadgate EC2

www.great-eastern-hotel.co.uk
www.conranandpartners.com

Terence Conran has integrated the hotel in a Victorian building complex directly adjacent to the train station. He turned the internal development axis and employed a spiral ramp as the central focal point. The respectful handling of existing assets and a distinct sense for that which is modern sets the tone of the building.

Terence Conran hat das Hotel in einen viktorianischen Gebäudekomplex direkt neben dem Bahnhof integriert. Er drehte die interne Erschließungsachse und setzte eine Spiralrampe als zentralen Blickfang ein. Der respektvolle Umgang mit dem Bestand und ein ausgeprägter Sinn für die Moderne prägen das Haus.

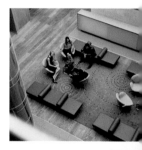

Terence Conran a intégré le hotel dans un complexe de bâtiments victoriens directement à proximité de la gare. Il a tourné l'axe d'aménagement interne et utilisé une rampe hélicoïdale comme objet central attirant le regard. L'harmonie respectueuse avec l'architecture existante et un sens prononcé de la modernité caractérisent la maison.

Terence Conran ha integrado el hotel en un complejo de edificios victorianos justo al lado de la estación. Ha girado el eje de urbanización interno y ha colocado una rampa como punto de atracción central de la mirada. El edificio se caracteriza por el trato respetuoso con la antigua edificación al tiempo que se adopta una actitud moderna.

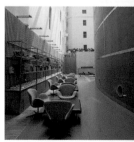

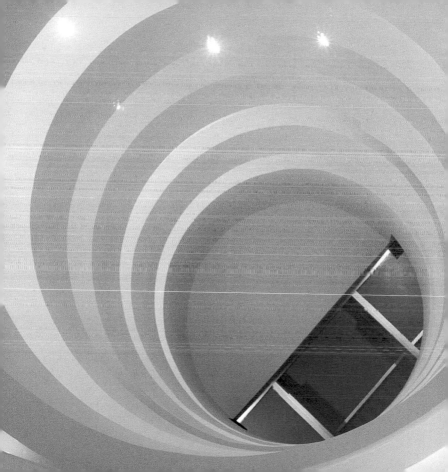

Threadneedles Hotel

GA Design

2002
5 Threadneedle Street
Barbican EC2

www.theetoncollection.com
www.gadesign.com

The old counter area of the stately bank building from the year 1856 creates the heart of the hotel. In the magnificent premises, GA Design has integrated a high-grade interior design of soft colors and forms by means of which a friendly and homely atmosphere has arisen.

Die alte Schalterhalle des stattlichen Bankgebäudes aus dem Jahre 1856 bildet heute das Herz des Hotels. GA Design hat in den prächtigen Räumlichkeiten eine hochwertige Innenarchitektur aus weichen Farben und Formen integriert, wodurch eine freundliche und wohnliche Atmosphäre entsteht.

L'ancien hall des guichets de l'immense bâtiment de banque construit en 1856 constitue aujourd'hui le coeur de l'hôtel. GA Design a intégré une architecture intérieure de haute qualité avec des couleurs tendres et des formes souples dans les magnifiques locaux, créant ainsi une atmosphère agréable et confortable.

El antiguo hall con mostradores del edificio del banco estatal del año 1856 es hoy el corazón de este hotel. GA Design ha integrado en las lujosas habitaciones una valiosa arquitectura interior hecha de suaves colores y formas que propicia una atmósfera agradable y acogedora.

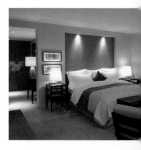

Myhotel Chelsea

James Soane for Project Orange

2002
35 Ixworth Place
Chelsea SW3

www.myhotels.co.uk
www.projectorange.com

The comfortable town palace is found situated on a quiet residential street in the middle of the elegant Brompton Cross shopping area. Here, Bohemian country-house style encounters modern glamour.

An einer ruhigen Wohnstraße inmitten der eleganten Einkaufsgegend Brompton Cross gelegen, befindet sich das behaglich Stadtpalais. Hier treffen bohemischer Landhausstil und zeitgemäßer Glamour zusammen.

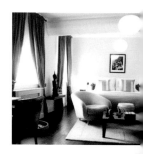

C'est sur une rue résidentielle calme au centre de l'élégant quartier commercial Brompton Cross que se trouve l'agréable palais municipal. Ici se rencontrent le style rustique bohémien et la séduction de la modernité.

Este confortable palacio urbano está situado en una tranquila calle residencial en medio de la elegante barriada comercial de Brompton Cross. Aquí se unen un bohemio estilo rústico con un sentido del glamour muy actual.

Sanderson

Philippe Starck, Michael Nash Associates

2000
50 Berners Street
Soho W1

www.ianschragerhotels.com
www.philippe-starck.com

Before the historic architectural monument from the 60's was redesigned, the Sanderson Company showroom was located here. The artistic principle of the hotel is the collision of the French colonial style and minimalist design.

Vor der Umgestaltung des Baudenkmals aus den 60ern befand sich hier der Showroom der Firma Sanderson. Gestalterisches Prinzip des Hotels ist die Kollision aus französischem Kolonialstil und minimalistischem Design.

Avant la restructuration du monument protégé des années 60 se trouvait ici le Showroom, pièce d'exposition de la société Sanderson. Le principe de création de l'hôtel résulte de la collision du style colonial français et du design minimaliste.

Antes de la reforma del monumento de los años 60, aquí se enclavaba la sala de exposiciones de la empresa Sanderson. El principio creativo del hotel es el choque entre el estilo colonial francés y un diseño minimalista.

No. 5 Maddox Street

Baker Neville Design

1999
5 Maddox Street
Mayfair W1

www.living-rooms.co.uk

In the midst of fine shops and boutiques where the Soho and Mayfair districts meet, Maddox Street nestles into the cityscape. 12 ultramodern designed suites with a far-eastern touch are to be found in the red brick building with the number 5.

Inmitten der feinen Läden und Boutiquen, wo die Bezirke Soho und Mayfair aufeinander treffen, schmiegt sich die Maddox Street in das Stadtbild. In dem roten Ziegelsteingebäude mit der Nummer 5 finden sich 12 supermodern gestaltete Suiten mit fernöstlicher Note.

C'est au milieu des beaux magasins et des boutiques ou les arrondissements Soho et Mayfair se rencontrent que la Maddox Street se faufile dans l'image de la ville. Dans le bâtiment de briques rouges au numéro 5 se trouvent 12 suites de conception ultramoderne avec une note orientale.

Entre elegantes tiendas y boutiques, donde se encuentran los distritos de Soho y Mayfair, se encuadra Maddox Street en el plano de la ciudad. El edificio de ladrillo rojo con el número 5 aloja 12 suites equipadas con todos los adelantos técnicos y una nota del Extremo Oriente.

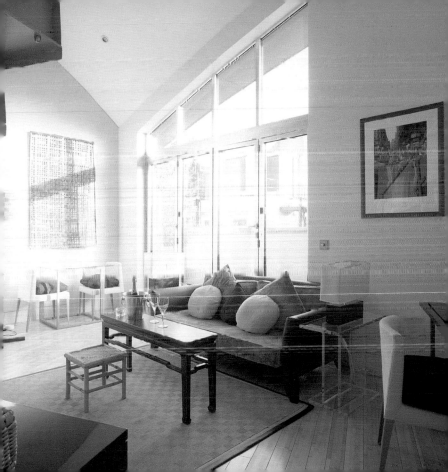

Sherlock Holmes Hotel

EAA International

2001
108 Baker Street
Marylebone W1

www.sherlockholmeshotel.com

The Sherlock Holmes is a modern building conceived with a feeling for modern design. References to the famous detective pursue the guest with subtle winks. In this sense, the chambermaid lays a small brainteaser next to the pillow every morning.

Das Sherlock Holmes ist ein modernes, mit Gefühl für zeitgemäße Gestaltung konzipiertes Haus. Referenzen an den berühmten Detektiv verfolgen den Gast mit subtilem Augenzwinkern. So legt allmorgendlich das Zimmermädchen eine kleine Denkaufgabe neben das Kopfkissen.

L'hôtel Sherlock Holmes est un immeuble moderne, conçu avec du sentiment pour l'équipement moderne. Les références au célèbre détective poursuivent le client avec des clins d'oeils subtils. Ainsi, chaque matin, la femme de chambre pose un petit exercice de réflexion à côté de l'oreiller.

El Sherlock Holmes es un moderno establecimiento, concebido con sensibilidad para darle un carácter acorde con los tiempos. Referencias al célebre detective acechan al huésped con sutiles guiños. Así por ejemplo, la doncella deja cada mañana un pequeño problema de ingenio junto a la almohada.

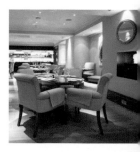

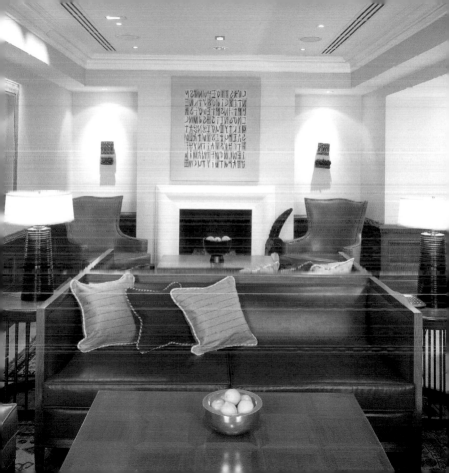

The Metropolitan

United Designers

1997
19 Old Park Lane
Mayfair W1

www.metropolitan.co.uk
www.united-designers.com

The Metropolitan clearly stands out from the mass of hotels in Mayfair. The order to the designer was simple: they should take hold of a blank piece of paper and design a hotel that meets the wishes and needs of the modern traveller. The Met Bar is a favourite hangout for fashion conscious Londoners.

Aus der Masse der Hotels in Mayfair sticht das Metropolitan klar heraus. Der Auftrag an die Designer war einfach: sie sollten ein leeres Blatt Papier zur Hand nehmen und ein Hotel gestalten, das die Wünsche und Bedürfnisse des modernen Reisenden trifft. Die Met Bar ist ein beliebter hang-out für modebewusste Londoner.

Le Metropolitan se distingue clairement de la masse des hôtels de Mayfair. La mission aux designers était claire: ils devaient prendre une feuille de papier blanc et créer un hôtel qui remplit les souhaits et les besoins des voyageurs modernes. Le bar du Met est un lieu de rencontre apprécié pour les Londoniens s'intéressant pour la mode.

Entre la multitud de hoteles de Mayfair, el Metropolitan destaca claramente. El encargo planteado a los diseñadores era simple: tomen una hoja de papel en blanco y diseñen un hotel que satisfaga los deseos y necesidades del viajero moderno. El Met Bar es un local popular entre los londinenses más a la moda.

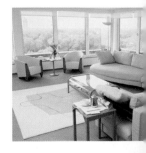

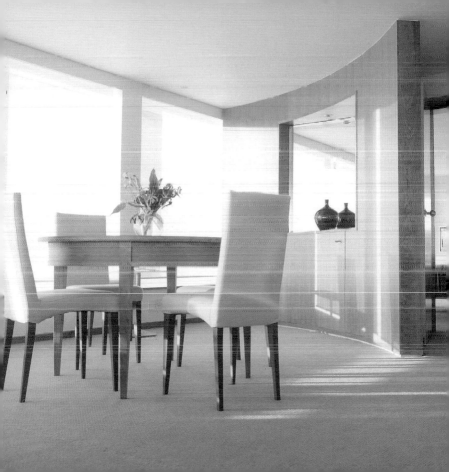

One Aldwych

Gordon Campbell Gray, Mary Fox-Linton,
Jestico + Whiles

1998
1 Aldwych
Covent Garden WC2

www.onealdwych.com
www.jesticowhiles.co.uk

Jestico + Whiles have developed the interior of One Aldwych in slender minimalism. The shell for this was supplied by the former headquarters of the Morning Post. Arrival in the 5-star house follows through a two-storey foyer in cool, white stone with delicate wooden window frames. The highlight is the swimming pool in the basement.

Jestico + Whiles haben die Innenräume des One Aldwych in schlankem Minimalismus ausgestaltet. Die Hülle dafür lieferte das ehemalige Hauptquartier der Morning Post. Die Ankunft in dem 5-Sterne-Haus erfolgt durch ein zweigeschossiges Foyer in kühlem, weißem Stein mit zarten hölzernen Fensterrahmen. Highlight ist das Schwimmbad im Untergeschoss.

Jestico + Whiles ont aménagé les locaux intérieurs du One Aldwych dans un minimalisme élancé. L'écrin à cet effet a été fourni par l'ancien quartier principal du Morning Post. L'arrivée à l'hôtel 5 étoiles s'effectue dans un foyer à deux étages en pierre blanche et froide avec de doux battants de fenêtres en bois. L'attraction est constituée par la piscine en sous-sol.

Jestico + Whiles han conformado los espacios interiores del One Aldwych en un elegante minimalismo. El escenario para ello lo proporciona la antigua sede central del Morning Post. La llegada a este establecimiento de 5 estrellas se produce a través de un vestíbulo de dos plantas en piedra blanca fría y ventanas con delicados marcos de madera. Destaca la piscina en la planta de sótano.

St Martins Lane

Philippe Starck

1999
45 St. Martin's Lane
Covent Garden WC2

www.ianschragerhotels.com
www.philippe-starck.com

A building occupies St Martins Lane in which formerly, among others, the Mickey Mouse Club and the famous Lumière cinema were at home. One enters the building through a greatly raised glass revolving door. The lobby is a sequence of open, connected, and distinctly differently designed rooms.

St Martins Lane belegt ein Gebäude, in dem vormals unter anderem der Mickey Mouse Club und das berühmte Lumière Lichtspielhaus zuhause waren. Man betritt das Haus durch eine stark überhöhte Glasdrehtür. Die Lobby ist eine Abfolge von offenen, miteinander verbundenen und betont unterschiedlich gestaltenen Räumen.

St Martins Lane occupe un bâtiment dans lequel notamment le club Mickey Mouse et la célèbre maison de jeux lumineux Lumière ont eu leur siège autrefois. On pénètre dans la maison grâce à une porte en verre de très grande hauteur. Le hall d'entrée est une suite de pièces ouvertes reliées les unes entre les autres et intentionnellement différentes.

St Martins Lane ocupa un edificio que albergó anteriormente, entre otros, el Mickey Mouse Club y el famoso cinematógrafo Lumière. Se accede al establecimiento a través de una puerta giratoria de vidrio de gran altura. El lobby es una sucesión de salas abiertas, conectadas entre sí y decoradas de forma marcadamente distinta.

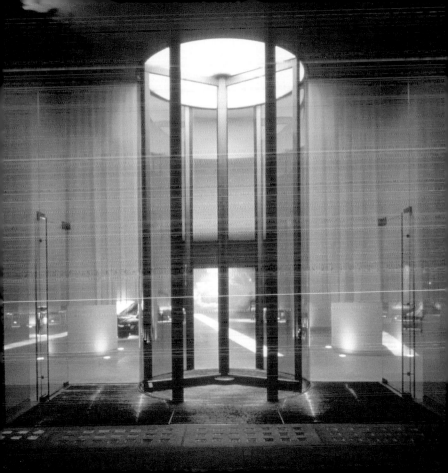

to go . eating
drinking
clubbing
wellness, beauty & sport

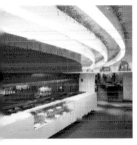

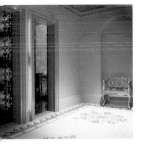 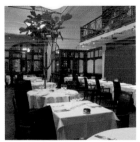

Plateau

Conran & Partners

2003
4th Floor, Canada Place
Canary Wharf E14

www.conran-restaurants.co.uk

The Plateau consists of two dining areas, which are separated by a main, half-open kitchen. They each possess an own bar and terrace. They are furnished with design classics. Eero-Saarinen tulip chairs and tables with Italian marble slabs fetch a flair of the 50's to Canary Wharf.

Das Plateau besteht aus zwei Speisebereichen, die durch eine zentrale, halboffene Küche getrennt sind. Sie verfügen jeweils über eine eigene Bar und Terrasse. Möbliert sind sie mit Designklassikern. Eero-Saarinens Tulip-Stühle und Tische mit italienischen Marmorplatten holen hier ein Flair der 50er Jahre nach Canary Wharf.

Le plateau est constitué de deux zones de restauration séparées par une cuisine centrale semi ouverte qui disposent chacune d'un bar et d'une terrasse. Elles sont meublées avec des classiques de designs. Les tables et chaises-tulipes d'Eero-Saarinen avec des plaques de marbre italiennes y amènent un flair des années 50 à Canary Wharf.

El Plateau consta de dos zonas de comedor separadas por una cocina central semiabierta. Cada una de ellas dispone de bar y terraza propios. Están amuebladas con clásicos del diseño. Las sillas de tulipa de Eero Saarinen y las mesas con placas de mármol italiano recuperan el encanto de los años 50 a lo Canary Wharf.

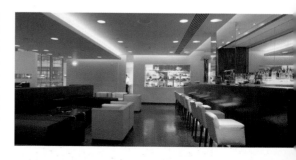

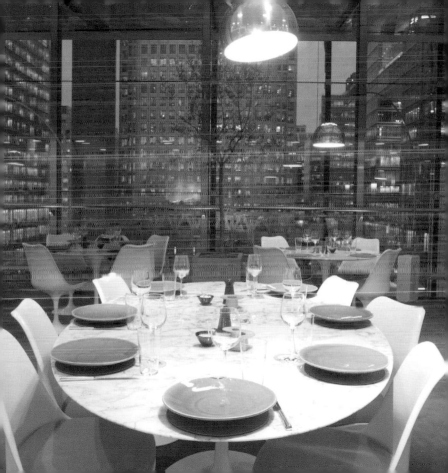

Tower 42

Fletcher Priest Architects
Waterman Group plc

1999
25 Old Broad Street
Broadgate EC2

www.tower42.com
www.fletcherpriest.com

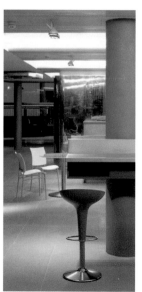

There are very many passers-by in the ground floor of the tower. That is why the Café Zero is located here—ideal for a quick snack or an informal meeting. Halfway up there is a very nice restaurant with a panoramic view. The high-class designed champagne bar Vertigo 42 has a view of the entire city.

Au rez-de-chaussée de la tour, il y a énormément de passants. C'est pourquoi se trouve ici le Café Zero, idéal pour un snack rapide ou un rendez-vous informel. A mi-chemin vers le haut se trouve un très beau restaurant panoramique. Le bar de champagne Vertigo 42 aménagé avec goût domine toute la ville.

Im Erdgeschoss des Turmes gib es sehr viele Passanten. Deshal befindet sich hier das Café Zero ideal für einen schnellen Snack oder ein informelles Treffen. Au halbem Weg nach oben gibt e ein sehr schönes Aussichtsres taurant. Die hochwertig gestal tete Champagnerbar Vertigo 4 überblickt die ganze Stadt.

La planta baja de la torre recib a muchos paseantes. Por es alberga el Café Zero, ideal par un aperitivo rápido o una cita in formal. A medio camino haci arriba encontramos un precios restaurante-mirador. Desde el lu josamente decorado bar-cham pañería Vertigo 42 se contempl toda la ciudad.

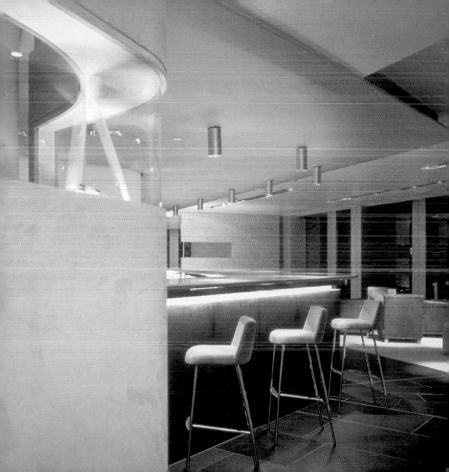

The Cinnamon Club

David Gabriel

2001
The Old Westminster Library,
Great Smith Street
Westminster SW1

www.cinnamonclub.com

During the design of the Indian restaurant in the former Westminster library from 1897, David Gabriel preserved historic elements such as the parquet floor and the wooden bookshelves. In combination with new materials such as Indian stone and leather, a kind of contemporary colonial style has emerged.

David Gabriel hat bei der Gestaltung des indischen Restaurants in der ehemaligen Westminster Library aus dem Jahre 1897 historische Elemente wie den Parkettboden und die hölzernen Bücherregale erhalten. In Kombination mit neuen Materialien wie indischem Stein und Leder entsteht eine Art kontemporärer Kolonialstil.

Lors de l'aménagement du res taurant indien dans l'ancienn bibliothèque de Westminste construite en 1897, David Ga briel a conservé des élément historiques commo lo col on par quet et les étagères en bois pou les livres. En combinaison avec de nouveaux matériaux comme la pierre indienne et le cuir es créé une sorte de style colonia contemporain.

David Gabriel ha mantenido para la decoración del restaurante indio en la antigua biblioteca de Westminster del año 1897 diversos elementos históricos, como el suelo de parquet y los estantes de madera para libros. La combinación con nuevos materiales como la piedra y el cuero indios da como resultado una especie de estilo colonial contemporáneo.

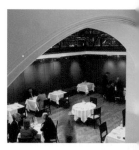

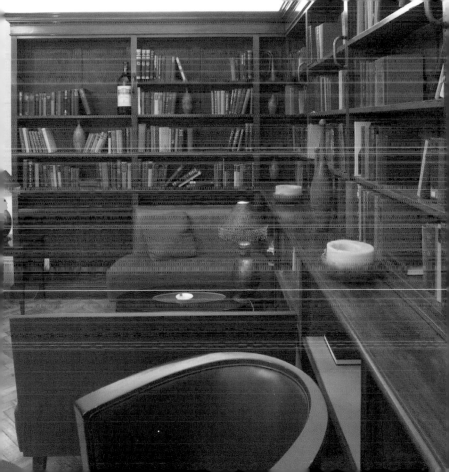

Fifth Floor

Lifschutz Davidson

2002
109-125 Knightsbridge
Knightsbridge SW1

www.harveynichols.com
www.lifschutzdavidson.com

The restaurant situated up in the fifth floor of the Harvey Nichols luxury department store marks the return to large dining halls. The strictness of the elliptical space is dispersed through recessed niches. Colour iridescent pipes define the walls, a crisscross running design of sand blasted panels, the ceiling.

Das im fünften Stock des Nobelkaufhauses Harvey Nichols liegende Restaurant markiert die Rückkehr zu den großen Speisesälen. Die Strenge des elliptische Raumes wird durch ausgesparte Nischen aufgelöst. Farblich changierende Röhren definieren die Wände, ein kreuz und quer verlaufendes Muster aus sandgestrahlten Paneelen die Decke.

Le restaurant situé au cinquième étage du grand magasin de luxe Harvey Nichols marque le retour aux grandes salles communes. L'austérité de la pièce elliptique est dissipée par des niches évidées. Des tubes changeant de couleur définissent les murs, une figure disposée dans tous les sens et constituée de panneaux sablés le plafond.

Este restaurante, situado en la quinta planta por encima de los elegantes almacenes Harvey Nichols, marca el regreso de los grandes comedores. La austeridad de la sala elíptica se compensa con rincones entallados. Tubos de colores tornasolados definen las paredes, el techo es un dibujo en zig-zag formado por paneles de chorro de arena.

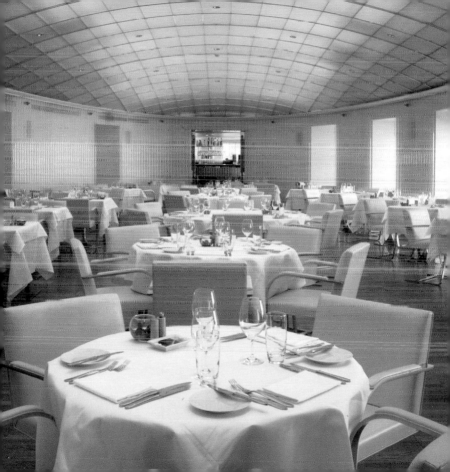

Chintamani

Zeynep Fadillioglu

2002
122 Jermyn Street
St. James's SW1

www.chintamanilondon.com

The first-class Chintamani, provided with its Bedouin tent-like ceiling, is one of the most beautiful, oriental designed restaurants in London Westend. The Ottoman furniture and fabrics create an ambience as traditional as it is noble.

Das erstklassige, mit einer beduinenzeltartigen Decke versehene Chintamani, ist eines der schönsten, orientalisch gestalteten Restaurants des Londoner Westends. Die osmanischen Möbel und Stoffe schaffen ein ebenso traditionelles, wie edles Ambiente.

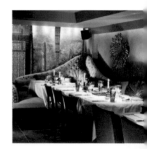

Le Chintamani, restaurant de première classe pourvu d'un plafond rappelant les tentes de bédouins est l'un des plus beaux restaurants d'aménagement oriental du Westends londonien. Les meubles et étoffes ottomans créent une ambiance tout aussi traditionnelle que raffinée.

El exclusivo Chintamani, con su techo en forma de tienda beduina, es uno de los más hermosos restaurantes de diseño oriental del West End londinense. Los muebles y tejidos otomanos crean un ambiente tan tradicional como elegante.

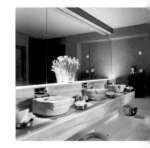

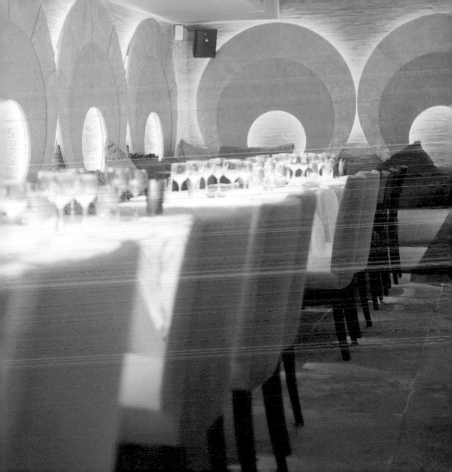

Café Consort
Royal Albert Hall

Softroom

2003
Kensington Gore
South Kensington SW7

www.royalalberthall.com
www.softroom.com

Four large restaurant rooms punctiliously embrace the main auditorium. The main area with the jointless monolithic white bar links the new south entrance with the dining rooms. The upholstered red velvet wall is based on the plush interior of the hall.

Vier große Restauranträume umschlingen das zentrale Auditorium förmlich. Der zentrale Bereich mit der fugenlos monolithischen weißen Bar verknüpft das neue Südportal mit den Speiseräumen. Die gepolsterte rote Samtwand bezieht sich auf das plüschige Interieur der Halle.

Quatre grandes salles de restaurants embrassent l'auditorium central. La zone centrale avec le bar blanc monolithique sans joints relie le nouveau portail sud aux salles de restauration. Le mur en velours capitonné rouge s'inspire de l'intérieur pelucheux du hall.

Cuatro grandes comedores envuelven el auditorio central. La zona central, con su blanca barra monolítica, une el nuevo portal sur con los comedores. La tapizada pared de terciopelo rojo remite al interior afelpado del hall.

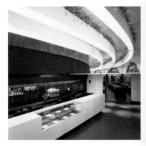

138

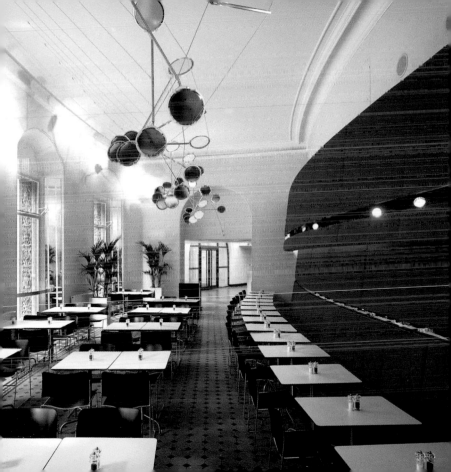

Zuma

Noriyoshi Muramatsu for Super Potato, Tokyo

2002
5 Raphael Street
Knightsbridge SW7

www.zumarestaurant.com

The Zuma portrayed by Japanese designers depicts a gentle convergence of the traditional Japanese Izakya style with the European way of life. The open kitchen with a dining bar is integrated into the restaurant. Wooden Shoji walls define the more private eating area with sunken Kotatsu tables.

Das von japanischen Designern entworfene Zuma stellt eine sanfte Annäherung des traditionellen japanischen Izakya-Stils an die europäische Lebensweise dar. Die offene Küche mit Essbar ist in das Restaurant integriert. Hölzerne Shoji-Wände definieren privatere Essbereiche mit abgesenkten Kotatsu-Tischen.

La zuma dessinée par des designers japonais représente une approche douce du style japonais traditionnel Izakya de la manière de vivre européenne. La cuisine ouverte avec bar de restauration est intégrée dans le restaurant. Des murs Shoji en bois délimitent des zones de restauration privées avec des tables Kotatsu basses.

El Zuma, concebido por diseñadores japonenses, representa una suave aproximación del tradicional estilo japonés Izakya al modo de vida europeo. La cocina abierta con barra está integrada en el restaurante. Paredes de madera Shoji definen espacios más privados para comer con mesas bajas Kotatsu.

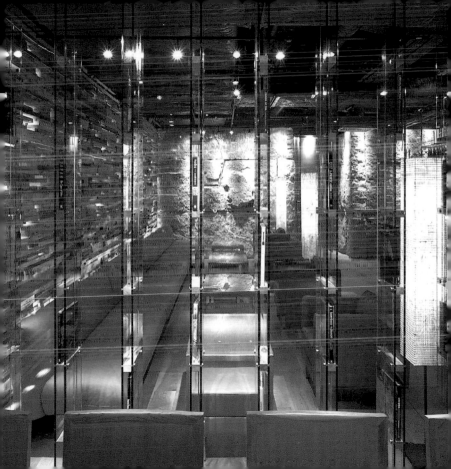

Hakkasan

Jestico + Whiles, Christian Liaigre

2002
8 Hanway Place
Bloomsbury W1

www.jesticowhiles.co.uk

In Hakkasan, traditional Chinese motifs and a clearly modern aesthetic join together. The discrete entrance is marked by only a red silk lantern. A crepuscular, slate covered stairway leads to a mystical restaurant with cobalt blue glass walls.

Im Hakkasan finden traditionelle chinesische Motive und eine deutlich moderne Ästhetik zusammen. Der diskrete Eingang wird nur von einer roten Seidenlaterne markiert. Ein dämmriges, schieferverkleidetes Treppenhaus führt in ein mystisches Restaurant mit kobaltblauen Glaswänden.

Au Hakkasan se réunissent des motifs chinois traditionnels et une esthétique de modernité claire. L'entrée discrète n'est marquée que par une lanterne de soie rouge. Une cage d'escalier crépusculaire revêtue d'ardoise mène à un restaurant mystique avec murs de verre bleu cobalt.

El Hakkasan combina motivos tradicionales chinos y una estética decididamente moderna. Su discreta entrada está marcada únicamente por un farol de seda rojo. Una escalera en penumbra, revestida de pizarra, conduce a un místico restaurante con paredes de cristal azul cobalto.

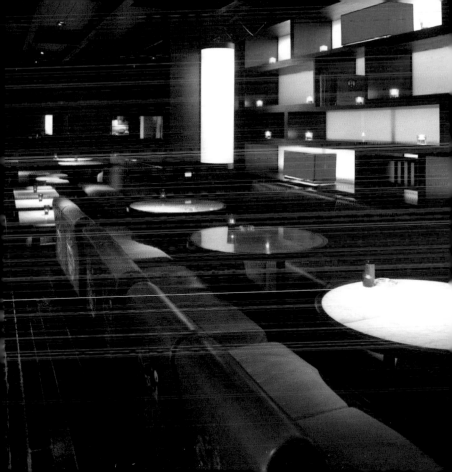

Sketch

Mourad Mazouz, Gabban O'Keefe, Noe Duchaufour Lawrance,
Marc Newson, Chris Levine & Vincent Le Roy

2002
9 Conduit Street
Mayfair W1

As already indicated by the name, the Sketch is a concept undergoing constant change. In its breathtaking appearance, the continuously self-overtaking design of both restaurants with bar and the art gallery belonging to it is a fantastically designed snapshot.

Wie der Name bereits andeutet, ist das Sketch ein in stetigem Wandel befindliches Konzept. Die sich ständig selbst überholende Gestaltung der beiden Restaurants mit Bar und dazugehöriger Kunstgalerie ist in ihrer berauschenden Erscheinung eine phantastisch gestaltete Momentaufnahme.

Comme le nom l'indique, le sketch est un concept en mutation constante. L'aménagement se dépassant constamment lui-même des deux restaurants avec bar et galerie artistique attenante fait vivre l'instant présent avec une volupté fantastique.

Como ya advierte su nombre, la idea del Sketch es el cambio continuo. La decoración en constante renovación de los dos restaurantes con bar y galería de arte se antoja por su embriagador aspecto una fantástica instantánea.

144

Spoon at Sanderson

Philippe Starck

2000
50 Berners Street
Soho W1

www.spoon-restaurant.com
www.philippe-starck.com

The Spoon at Sanderson is the light coloured, remotely directed establishment of the first rate cook, Alain Ducasse. Dark grey, rough-hewn reinforced steel pillars contrast with the snow-white tablecloths. During pleasant weather, the flower filled free area in the inner courtyard of the building from the 60's is also open.

Das Spoon at Sanderson ist die in hellen Farben gehaltene, fern-diktierte Niederlassung des Spitzenkochs Alain Ducasse. Dunkelgraue, grob behauene Stahlbetonsäulen kontrastieren mit den schneeweißen Tisch-tüchern. Bei guter Witterung ist auch der mit Blumen gefüllte Freibereich im Innenhof des 60er Jahre Hauses geöffnet.

Le Spoon at Sanderson est la fi-liale maintenue en couleurs clai-re et dictée de loin du cordon bleu Alain Ducasse. Des piliers en béton armé de construction grossière, gris foncés contras-tent avec les serviettes de table d'un blanc de neige. Par beau temps, la zone de plein air rem-plie de fleurs dans la cours inté-rieure de la maison des années 60 est aussi ouverte.

El Spoon at Sanderson es la su-cursal a distancia, mantenida en tonos claros, del extraordinario chef Alain Ducasse. Los pilares de hormigón al acero gris oscu-ro toscamente labrados contras-tan con los manteles de un blan-co impoluto. Cuando hace buen tiempo se abre también la zona al aire libre decorada con flores del patio interior años 60.

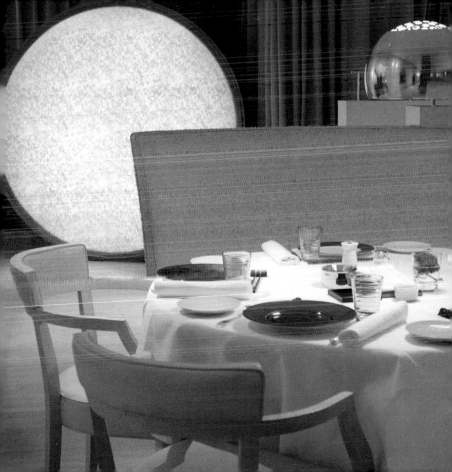

Nobu

United Designers

1997
19 Old Park Lane
Mayfair W1

www.noburestaurants.com
www.united-designers.com

Robert de Niro's Nobu is to be found in the first upper floor of the Metropolitan Hotel. The separate entrance to the noble Japanese restaurant lies on Old Park Lane. The room is divided by rounded pillars, which is why it has the effect of being quite leisurely despite its 150 settings.

Robert de Niros Nobu befindet sich im ersten Obergeschoss des Metropolitan Hotels. Der separate Zugang des edlen japanischen Restaurants liegt auf der Old Park Lane. Der Raum wird durch abgerundete Pfeiler gegliedert, weshalb er trotz der 150 Gedecke recht beschaulich wirkt.

Le Nobu de Robert de Niro se trouve au premier étage du Metropolitan Hotel. L'entrée indépendante du restaurant japonais raffiné se trouve sur la Old Park Lane. La salle est partagée par des piliers arrondis et elle fait pour cette raison un effet plutôt contemplatif malgré ses 150 couverts.

El Nobu de Robert de Niro se halla en la primera planta del Hotel Metropolitan. A este lujoso restaurante japonés se accede separadamente por Old Park Lane. Pilares redondeados dividen el espacio, dando un ambiente de recogimiento a pesar de su capacidad para 150 cubiertos.

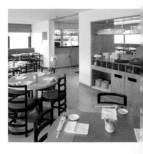

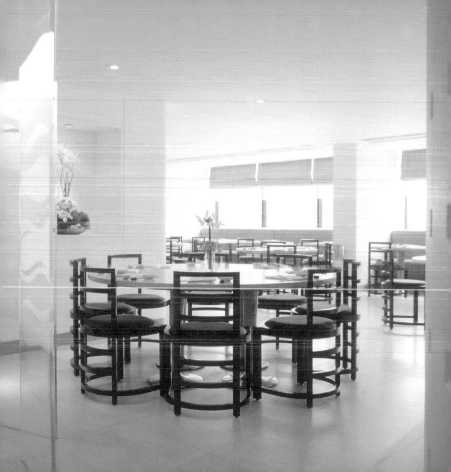

Asia de Cuba

Philippe Starck

1999
45 St. Martin's Lane
Covent Garden WC2

www.asiadecuba.com
www.philippe-starck.com

Powerful "artistic columns" characterise the room. Here, everything that pleases, from photography to radio, is exhibited. The tables and chairs spread around the maple floor are equally dressed in white. A bizarre combination of Asian and Latin American cuisine is found on the menu.

Mächtige „Kunstsäulen" bestimmen den Raum, hier wird von der Fotografie bis zum Radio alles ausgestellt was gefällt. Die auf dem Ahornparkett verteilten Tische und Stühle sind gleichermaßen weiß gekleidet. Auf der Speisekarte findet sich eine skurrile Kombination aus asiatischer und lateinamerikanischer Küche.

Des colonnes artistiques puissantes définissent l'espace, ici est exposé tout ce qui plait, de la photographie à la radio. Les tables et les chaises réparties sur le parquet en érable sont habillées de blanc dans une mesure semblable. Sur la carte se trouve une combinaison bouffonne de cuisine asiatique et latino-américaine.

Poderosas "columnas artísticas" definen el espacio: aquí se expone todo lo que cae en gracia, desde fotografías a una radio. Las mesas y sillas repartidas sobre el parquet de arce están vestidas igualmente de blanco. La carta contiene una divertida combinación de cocina asiática y latinoamericana.

The Workhouse Community Sports Centre

Proctor and Matthews Architects
Techniker

1999
Poplar High Street
Poplar E14

www.proctorandmatthews.com

Open to the public. The pergola-like canopy serves as a mediator between the street zone and the building. In the lowered yard, childrens' groups and school classes find an outdoor schoolroom. In accordance with the seasons the entrance hall can be completely opened to the outside.

Offen für die Öffentlichkeit. Das pergolaähnliche Vordach dient als Vermittler zwischen Straßenraum und Gebäude. In dem abgesenkten Hof finden Kindergruppen und Schulklassen ein Freiluftklassenzimmer. Den Jahreszeiten entsprechend kann sich die Einganghalle komplett nach außen öffnen.

Ouvert au public. Le auvent façon pergola sert de médiateur entre l'espace de la rue et le bâtiment. Dans la cour abaissée, les groupes d'enfants et les classes scolaires trouvent une salle de classe en plein air. En fonction des saisons, le hall d'entrée peut s'ouvrir complètement vers l'extérieur.

Abierto al público. El alero en forma de pérgola hace las veces de intermediario entre el espacio de la calle y el edificio. El patio, a inferior nivel, sirve como aula al aire libre para grupos de niños y clases escolares. Según las estaciones, el hall de entrada se puede abrir completamente al exterior.

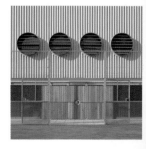

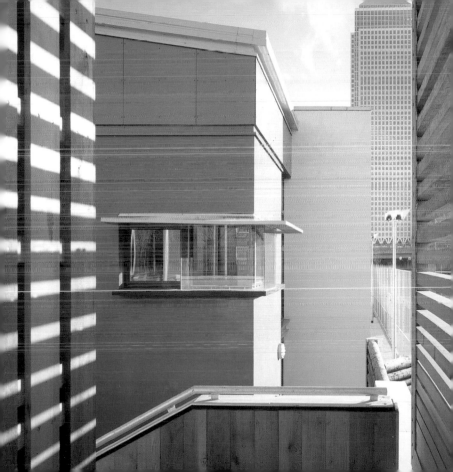

London Regatta Centre

Ian Ritchie Architects
Ove Arup and Partners

2000
Royal Albert Dock
Dockside Road
Canning Town E16

www.docklands.regatta.org.uk
www.ianritchiearchitects.co.uk

The regatta centre is developing in an artistic landscape made of gabion walls. The boat and clubhouse integrate themselves into the landscape in different ways. Terraces and a second storey allow a view of the racetrack from the bar and restaurant.

Das Regattazentrum entwickelt sich in einer künstlichen Landschaft aus Gitterkorbwänden. Boots- und Clubhaus fügen sich in unterschiedlicher Weise in diese Landschaft ein. Terrassen und ein zweites Geschoss ermöglichen den Blick von Bar und Restaurant auf die Rennstrecke.

Le centre de régates s'épanouit dans un paysage artificiel de murs renforcés par paniers de grillage. Le hangar à bateaux et la maison du club s'insèrent de manière différente dans ce paysage. Des terrasses et un deuxième étage permettent la vue du bar et du restaurant sur la voie de courses.

El Centro de Regatas se extiende sobre un paisaje artificial de paredes de celosía. La casa de botes y el club se encuadran de manera diferente en este entorno. Las terrazas y la segunda planta permiten contemplar el recorrido de las regatas desde el bar y el restaurante.

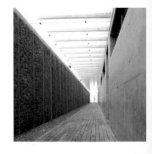

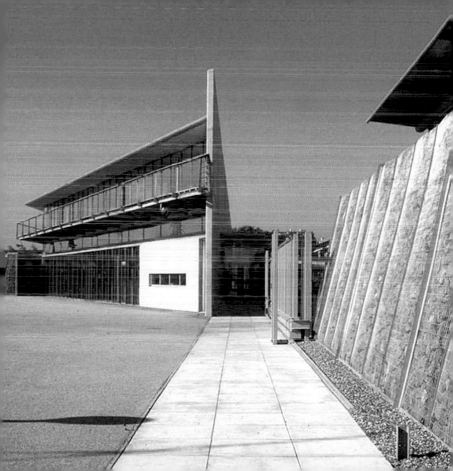

Lord's Cricket Ground Media Centre

Future Systems
Ove, Arup & Partners

1999
St. John's Wood Road
St. John's Wood NW8

www.lords.org
www.future-systems.com

Clear view for journalists. The Media Centre is suspended 15 meters over the stadium. Means and technology from shipbuilding made this semi-shell aluminum construction possible. As the only opening, the large glass façade steers the view from the cave-like interior to the pitch.

Blick frei für die Journalisten. Das Medienzentrum schwebt 15 Meter über dem Stadion. Mittel und Technik des Bootsbau machten diese Halbschalenkonstruktion aus Aluminium möglich. Die große Glasfassade lenkt als einzige Öffnung den Blick aus dem höhlenartigen Innenraum auf das Spielfeld.

Vue libre pour les journalistes. Le centre médiatique flotte 15 mètres au-dessus du stade. Les moyens et la technique de construction en bateau ont rendu possible cette construction aluminium en demi-coque. En tant qu'ouverture unique de l'espace intérieur semblable à une caverne, la grande façade en verre attire le regard sur le terrain.

Vista libre para los periodistas. El centro de comunicaciones se alza 15 metros por encima del estadio. Los medios y la técnica de la construcción de barcos hicieron posible esta estructura semimonocoque en aluminio. La gran fachada de cristal dirige la mirada al campo de juego por la única abertura desde el espacio interior en forma de cueva.

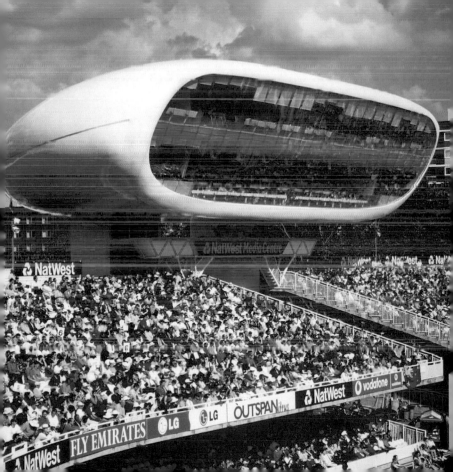

Lord's Cricket Ground Grand Stand

Grimshaw
Ove Arup & Partners

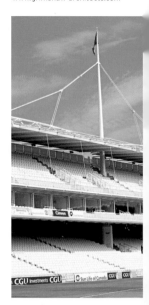

1998
St. John's Wood Road
St. John's Wood NW8

www.lords.org
www.grimshaw-architects.com

No construction element disturbs the view of the cricket game. Up to 6000 spectators find room on both terraces of the unparalleled light design. The dovolopmont on the north side brings the fans speedily to their goal. 25 boxes are available for guests of honour.

Kein konstruktives Element stört den Blick auf das Cricketspiel. Auf den beiden Rängen der beispiellos leichten Konstruktion finden bis zu 6000 Zuschauer Platz. Die Erschließung auf der Nordseite bringt die Fans zügig an ihr Ziel. Für Ehrengäste stehen 25 Logen zur Verfügung.

Aucun élément de construction ne trouble la vue sur le jeu de cricket. Les deux gradins de la construction légère sans exemple jusqu'à présent offrent de la place à jusqu'à 6.000 spectateurs. L'aménagement sur le côté nord amène rapidement les supporters à leur but. Pour les invités d'honneur se trouvent 25 loges à disposition.

Ningún elemento constructivo estorba la vista al campo de críquet. Las dos gradas de la construcción de ligereza sin igual dan cobijo a un máximo de 6000 espectadores. La apertura del lado norte conduce a los aficionados de forma fluida a sus localidades. Dispone de 25 palcos para huéspedes de honor.

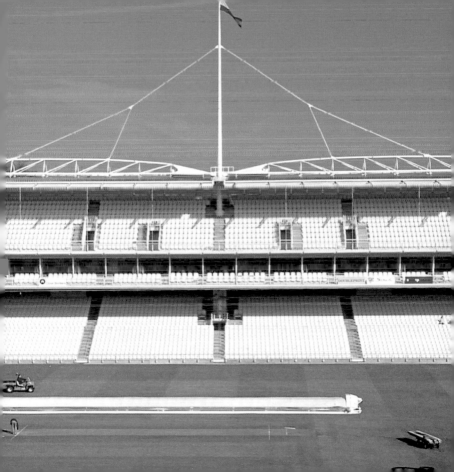

Chelsea Club

Fletcher Priest Architects
Adams Kara Taylor

2001
Fulham Road
Fulham SW6

www.thechelseaclub.com
www.fletcherpriest.com

Outside the first floor, an external racetrack surrounds the robust and qualitatively highgrade building. Translucent façade panelling ensures pleasant lighting of the rooms. The central development zone emphasises the continuity of the health and fitness areas.

Außerhalb des ersten Stocks umschließt eine externe Laufbahn das robuste und qualitativ hochwertige Gebäude. Transluzente Fassadenpaneele sorgen für eine angenehme Belichtung der Räume. Die zentrale Erschließungszone betont den Zusammenhang zwischen Gesundheits- und Fitnessbereichen.

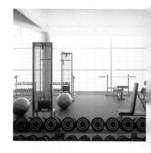

Au dehors du premier étage, le bâtiment robuste et de très haute qualité est entouré par un champ de course externe. Des panneaux de façade translucides confèrent un éclairage agréable aux locaux. La zone d'aménagement centrale souligne le rapport entre les secteurs de la santé et du fitness.

En el exterior de la primera planta, una pista externa envuelve el robusto y cualitativamente avanzado edificio. Los paneles traslúcidos de la fachada procuran una agradable iluminación a las salas. La zona habilitada central acentúa la unidad entre las áreas de salud y fitness.

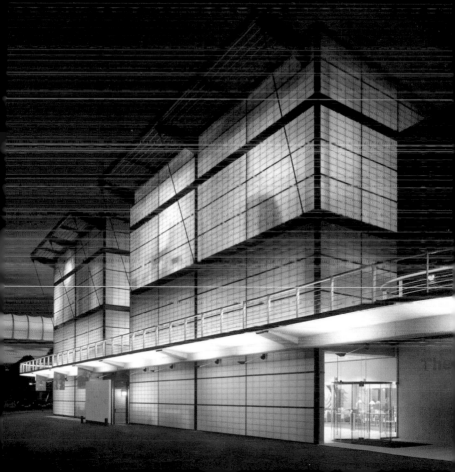

to shop . mall
retail
showrooms

 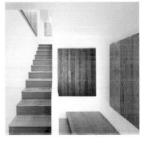 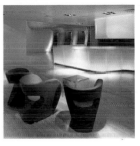

163

Ebony and Co. Showroom

Softroom

2002
198 Ebury Street
Pimlico SW1

www.ebonyandco.com
www.softroom.com

The two-storey Ebony and Co. Showroom is used for the presentation of high quality, handmade wooden floors. A long descending ground floor room is divided into a succession of four areas, each covered with a different wood. The mirrors enlarge the optical effect of the floor coverings.

Der zweigeschossige Ebony and Co. Showroom dient der Präsentation hochwertiger, handgefertigter Holzböden. Ein langer, abfallender Erdgeschossraum ist in eine Abfolge von vier Bereichen gegliedert, jeder mit einem anderen Holz ausgelegt. Die Spiegel vergrößern die optische Wirkung der Bodenbeläge.

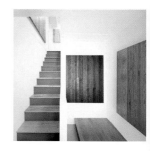

L'Ebony and Co. Showroom, salle d'exposition à deux étages, sert à la présentation de parquets de haute qualité faits main. Un long espace de rez-de-chaussée séparé est divisé en une suite de quatre secteurs, chacun ayant pour sol un bois différent. Les miroirs agrandissent l'effet optique des revêtements de sol.

Las dos plantas de la Ebony and Co. Showroom sirven para la presentación de valiosos suelos de madera realizados a mano. Una larga sala en declive en la planta baja se articula como una sucesión de cuatro áreas, cada una de ellas con una madera distinta. Los espejos aumentan el efecto óptico de los revestimientos de suelos.

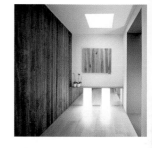

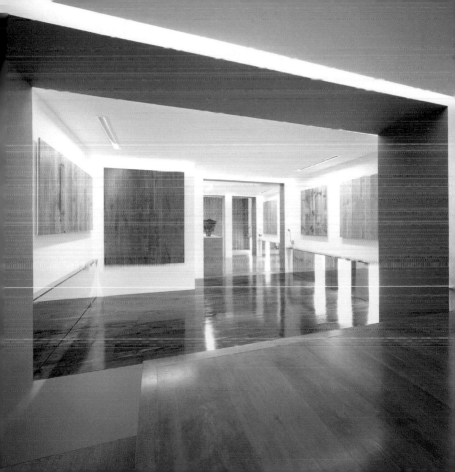

Chloé New Store Concept

London Flagship Store

Sophie Hicks, SH Ltd Architects
FJ Samuely and Partners

2002
152-153 Sloane Street
South Kensington SW1

www.chloe.fr
www.sophiehicks.com

Chloé wants to be young, sexy, and luxurious. In order to transform that into a design, the planners created strong contrasts. They combined high quality, almost even ostentatious materials with low-price goods. Thus, gold-leafed clothes hangers are placed in front of plywood slabs, which once protected a business building from riots.

Chloé will jung, sexy und luxuriös sein. Um das gestalterisch umzusetzen, haben die Planer starke Kontraste geschaffen. Hochwertige, fast schon protzige Materialien haben sie mit Billigware kombiniert. So stehen blattvergoldete Kleiderstangen vor Sperrholzplatten, die einmal ein Geschäftshaus vor Ausschreitungen schützten.

Chloé veut être jeune, sexy et luxueuse. Pour appliquer cela de manière créative, les architectes ont créés de forts contrastes. Des matériaux de haute qualité presque ostentatoires ont été combinés avec de la marchandise bon marché. Ainsi se trouvent des portemanteaux plaqués or devant des plaques de contreplaqué.

Chloé quiere ser joven, sexy y lujosa. Para llevar ese espíritu a su decoración, los proyectistas se han basado en contrastes fuertes. Han combinado materiales valiosos, casi arrogantes, con otros baratos. Así encontramos barras para colgar la ropa revestidas de oro en láminas frente a placas de contrachapado.

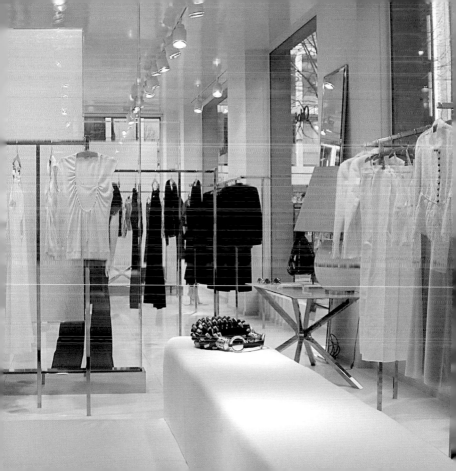

Giorgio Armani Store

Claudio Silvestrin
Techniker

2003
37-42 Sloane Street
South Kensington SW1

www.claudiosilvestrin.com

The entrance hall creates a gentle transition between the vague outside and the precise articulately designed sales area. The concept allows only a few high quality natural materials. Floors and walls are covered with St. Maxim limestone; the furniture is made of Macassar ebony and oxidized brass.

Die Eingangshalle bildet einen sanften Übergang zwischen dem unbestimmten Draußen und dem gestalterisch präzise artikulierten Verkaufsbereich. Das Konzopt crlaubt nur wenige hochwertige natürliche Materialien. Böden und Wände sind mit St. Maxim-Kalkstein belegt, die Möblierung besteht aus Makassar-Ebenholz und oxydiertem Messing.

Le hall d'entrée constitue un passage doux entre le dehors indéfini et la zone de vente précise articulée de manière créative. Le concept n'autorise que peu de matériaux naturels de haute qualité. Les sols et les murs sont revêtus de chaux St. Maxim, le mobilier est constitué d'ébène de Macassar et de laiton oxydé.

El vestíbulo crea una suave transición entre el espacio exterior indefinido y la zona de venta diseñada con articulada precisión. Este concepto sólo permite el uso de unos pocos materiales naturales de alta calidad. Los suelos y las paredes están revestidos de piedra caliza de St. Maxim, mientras que el mobiliario es de madera de ébano de Macassar y latón oxidado.

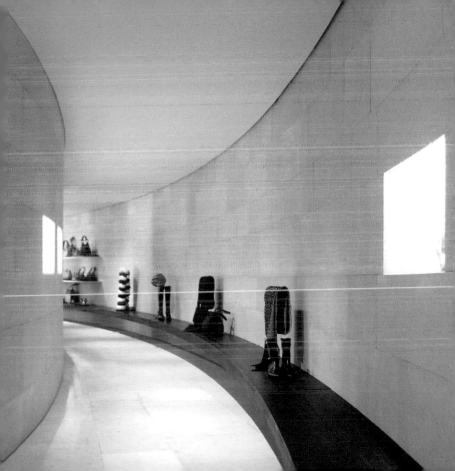

Oki-Ni

6a Architects
Jane Wernick Associates

2001
25 Savile Row
Mayfair W1

www.oki-ni.com
www.6a.co.uk

The design of the Oki—Ni is understood as a relation between consumer and product. Limited edition brand-name clothes are sold from the exhibition area exclusively online. Flat felt stacks and a revolving wooden wall replace the traditional stands, shelves, and poles.

Die Gestaltung des Oki–Ni versteht sich als Relation zwischen Konsument und Produkt. Limitierte Markenkleidung wird aus dem Ausstellungsraum heraus ausschließlich online verkauft. Flache Filzstapel und eine umlaufende, hölzerne Wand ersetzen die traditionellen Ständer, Regale und Stangen.

La conception de l'Oki–Ni s'entend comme relation entre le consommateur et le produit. Des vêtements de marque limités sont vendus hors du local d'exposition uniquement sur Internet. Des piles en feutre plat et un mur en bois sur tout le pourtour remplacent les portemanteaux, étagères et stands traditionnels.

La decoración de Oki–Ni se comprende como la relación entre el consumidor y el producto. La limitada ropa de marca se vende desde la sala de exposición exclusivamente on-line. Bajos aparadores de fieltro y una pared continua de madera sustituyen a las tradicionales perchas, estanterías y barras.

Camper Info Shop

Marti Guixe

1998
28 Old Bond Street
Mayfair W1

www.camper.com
www.guixe.com

Information and decoration are meant not only to flow into each other here but also to mutually replace one another. The decorative information is a parable about the Mallorcan donkey.

Information und Dekoration sollen hier nicht nur ineinander übergehen, sondern sich gegenseitig auch ersetzen. Die dekorative Information ist eine Parabel über Mallorcas Esel.

L'information et la décoration ne doivent pas seulement se fondre l'une dans l'autre, mais aussi se remplacer réciproquement. L'information décorative est une parabole sur l'âne de Majorque.

Información y decoración pretenden aquí no sólo mezclarse, sino incluso sustituirse mutuamente. La decorativa información utiliza el asno mallorquín como parábola.

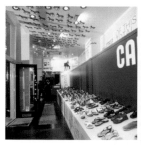

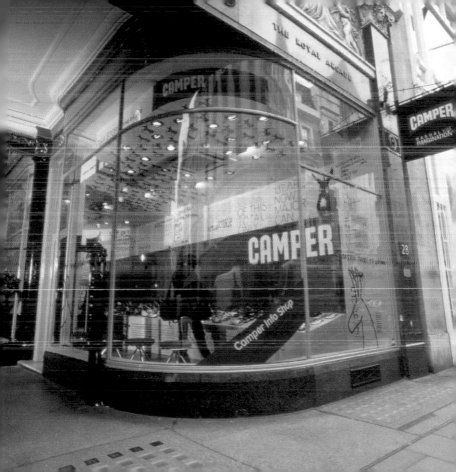

Stella McCartney Store

Barber Osgerby for Universal Design Studio
Price and Myers

2003
30 Bruton Street
Mayfair W1

www.stellamccartney.com
www.universaldesignstudio.com

The comfortable salesrooms also include a perfume room and the tailor's shop along with a VIP area with a garden. A monumental inlaid-work wall stretches over the entire depth of the main sales area. The wallpaper and the printed fabric walls are handmade, whereby the interior appears to be very personal.

Die behaglichen Verkaufsräume enthalten neben einem Parfümzimmer und der Schneiderei auch einen VIP-Bereich mit Garten. Eine monumentale Intarsienwand erstreckt sich über die gesamte Tiefe des Hauptverkaufsraums. Die Tapeten und die bedruckten Stoffwände sind handgefertigt, wodurch das Interieur sehr persönlich erscheint.

Outre une salle de parfumerie et un atelier de retouches, les espaces de vente contemplatifs contiennent également un secteur VIP avec jardin. Une cloison en marqueterie monumentale s'étend sur toute la profondeur de la salle de vente principale. Les tapisseries et les murs en tissu imprimé sont fabriqués à la main et confèrent à l'intérieur un effet très personnel.

Los acogedores espacios de venta incluyen, además de una sala de perfumes y la sastrería, una zona VIP con jardín. Una monumental pared de taracea se extiende hasta el fondo de la principal sala de venta. Las alfombras y los tapices estampados de las paredes están realizados a mano, lo que confiere un aspecto muy personal al interior.

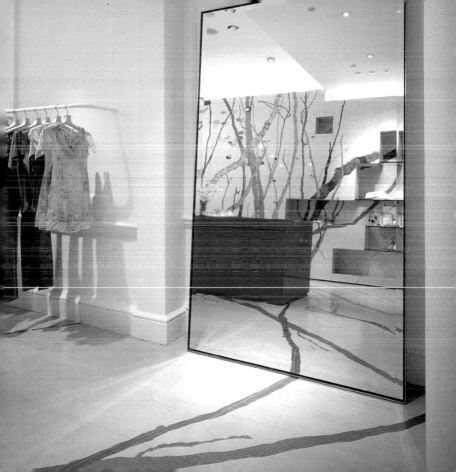

Sony Computer Entertainment Europe

Fletcher Priest Architects, Noble Associates
Dewhurst MacFarlane

2000
30 Golden Square
Soho W1

www.uk.playstation.com
www.fletcherpriest.com

The ground floor expands into an atrium in which a shining, somewhat arctic appearing "all-weather garden" is found. By blending construction components and functions, a virtual atmosphere is meant to emerge that is connected with the play stations to be sold.

Das Erdgeschoss dehnt sich in einen Lichthof aus, in dem sich ein leuchtender, etwas arktisch anmutender, „Allwettergarten" befindet. Durch das Verschmelzen von Bauteilen und Funktionen soll eine virtuelle Atmosphäre entstehen, die mit der zu verkaufenden Spielkonsole in Verbindung steht.

Le rez-de-chaussée s'étire dans une cour lumineuse dans laquelle se trouve un « jardin multi-climatique » illuminé et donnant une impression quelque peu arctique. Grâce la fusion des matériaux de construction et des fonctions doit être créée une atmosphère virtuelle, qui se trouve en relation avec les consoles de jeux à vendre.

La planta baja se extiende hasta un patio interior que alberga un luminoso "jardín de todo el año" de aspecto ligeramente ártico. Al fundirse componentes y funciones se crea una atmósfera virtual relacionada con las consolas de juego en venta.

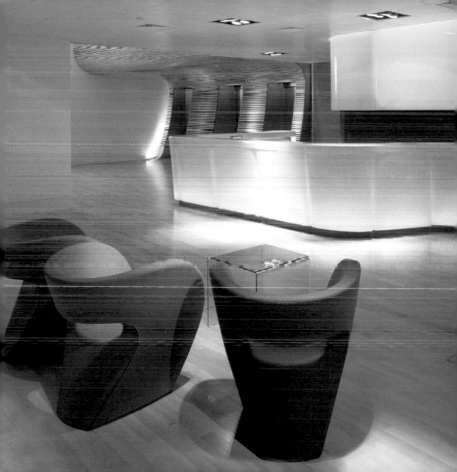

John Smedley

Softroom

2001
19 King's Road
Chelsea SW3

www.john-smedley.com
www.softroom.com

The ceiling and right wall of the showroom are covered with a coal-grey synthetic material. Through that, an absolutely flat surface is created, which quietly reflects the room. In order to optimally stage the collection the lighting of the fine knitwear is integrated into the furnishings.

Die Decke und rechte Wand des Showrooms sind mit einem kohlegrauen Kunststoffmaterial bespannt. Dadurch entsteht eine absolut ebene Oberfläche, die den Raum leise widerspiegelt. Um die Kollektion optimal zu inszenieren, ist die Beleuchtung der feinen Strickwaren in die Möblierung integriert.

Le plafond et le mur droit du showroom sont revêtus d'un matériau plastique anthracite. Une surface parfaitement plane est ainsi créée, qui reflète discrètement la pièce. Pour mettre en scène la collection de manière optimale, l'éclairage des vêtements en tricot fin est intégré dans le mobilier.

El techo y la pared derecha de la sala de exposición están revestidos con un material sintético gris oscuro. Se crea así una superficie absolutamente lisa que refleja suavemente el local. Para escenificar óptimamente la colección, la iluminación de los finos géneros de punto está integrada en el mobiliario.

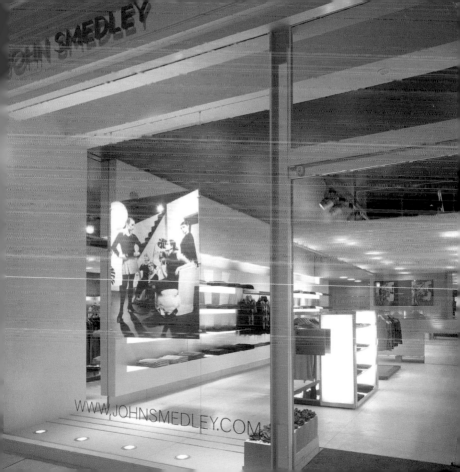

Index Architects / Designers

Index Structural Engineers

Index Districts

Photo Credits

Imprint

Copyright © 2004 teNeues Verlag GmbH & Co. KG, Kempen

Published by teNeues Publishing Group

teNeues Book Division
Kaistraße 18
40221 Düsseldorf, Germany
Phone: 0049-(0)211-99 45 97-0
Fax: 0049-(0)211-99 45 97-40
E-mail: books@teneues.de

teNeues Publishing Company
16 West 22nd Street
New York, N.Y. 10010, USA
Phone: 001-212-627-9090
Fax: 001-212-627-9511

teNeues Publishing UK Ltd.
P.O. Box 402
West Byfleet
KT14 77F, UK
Phone: 0044-1932-403 509
Fax: 0044-1932-403 514

Press department: arehn@teneues.de
Phone: 0049-(0)2152-916-202

www.teneues.com
ISBN 3-8238-4572-1

teNeues France S.A.R.L.
4, rue de Valence
75005 Paris, France
Phone: 0033-1-55 76 62 05
Fax: 0033-1-55 76 64 19

Bibliographic information published by Die Deutsche Bibliothek
Die Deutsche Bibliothek lists this publication in the Deutsche Nationalbibliografie;
detailed bibliographic data is available in the Internet at http://dnb.ddb.de

Edited and texts by Sabina Marreiros and Jürgen Forster
Concept by Martin Nicholas Kunz
Layout & Pre-press: Thomas Hausberg
Imaging: Florian Höch
Maps: go4media. – Verlagsbüro, Stuttgart

Translation: ADE-Team
English: Robert Kaplan
French: Ludovic Allain
Spanish: Margartia Celdràn-Kuhl

Printed in Italy

While we strive for utmost precision in every detail, we cannot be held responsible
for any inaccuracies neither for any subsequent loss or damage arising.

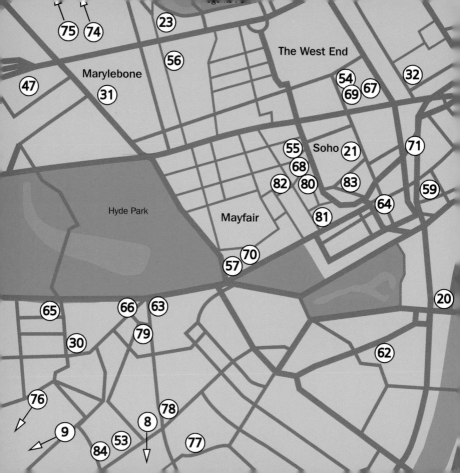

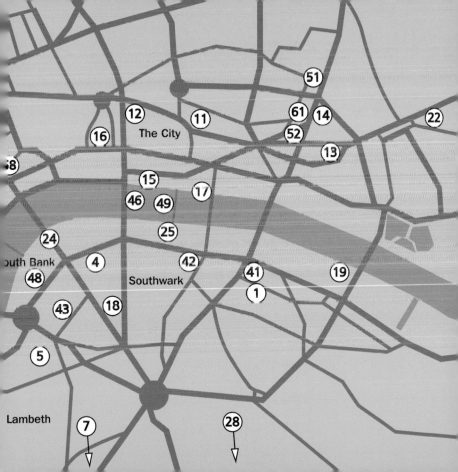

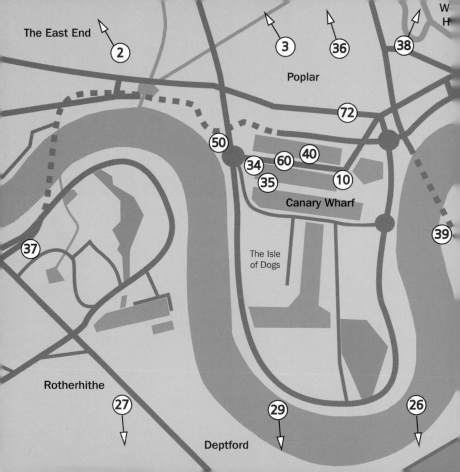